THE LITTLE BOOK OF

Miró

Constance Rubini
Frédéric Bodet

Flammarion

C O N T

The Story of Miró

Alphabetical Guide

Appendices

Alphabetical Guide

Entries are arranged alphabetically into the following three sections.
(Each section is indicated by a color code.)

The alphabetical entries are cross-referenced
throughout the text with an asterisk (*).

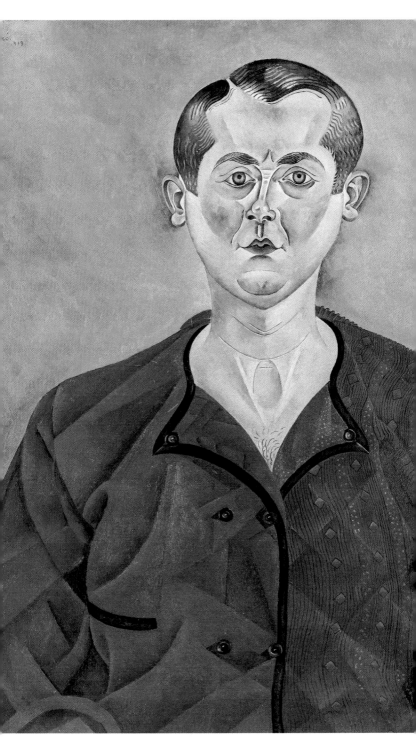

Self-Portrait, 1919, oil on canvas, 28 ¾ × 23 in. (73 × 60 cm).
Musée Picasso, Paris. Photo RMN/J. G. Berizzi.

THE STORY OF MIRÓ

"I should remind you that stagnation is the thing I most despise," Joan Miró informed a Catalan journalist in 1928. And, indeed, the painter's life and work were driven by endless self-renewal. For many years he divided his time between summers spent alone in the heart of the Catalan countryside, and more social, intellectually stimulating periods wintering in the city. In the same way, his work expresses a need to alternate between frenetic activity and intense clarity. He hovered between times when the sole subject of his inspiration was nature and others when he would draw essentially from an inner dream world.

Miró had begun drawing as a child, but his father, a prosperous goldsmith, had him register as a student in business school in 1907. This did not mean that Miró abandoned his pencils, however, and he was to follow courses at La Lonja school of fine art where, ten years previously, Picasso's talent had shone so brightly. One of the masters there became extremely important to him: this was Modesto Urgell, a man whose deeply expressive oeuvre, influenced by Arnold Böcklin, was in marked contrast to the academicism dispensed at the school. In 1910, Miró joined a hardware firm as a bookkeeper. Cooped up in accounts, the artist suffered in the oppressive atmosphere; indeed, his psychological distress was such that he fell ill. After this bout of depression, in about 1911 Miró made the decision to devote his life entirely to painting and enrolled in a course run by Francisc Gali, a visual artist who also believed in sensitizing his pupils to poetry and music. Gali helped Miró develop the use of all his senses, in particular teaching him how to draw an object from tactile observation alone, with eyes closed.

Miró's origins make abundantly clear the diversity of his sources: in cosmopolitan Barcelona he became acquainted with the artistic avant-garde, discovering Cézanne as well as the Fauves, Cubists, Expressionists, and Futurists. His letters at the time betray an abiding interest in the French avant-garde art promoted through specialized periodicals such as *Revista Nova* and *Nord-Sud*. He first experienced Cubist works at the Dalmau gallery, also encountering the Dada movement there. In January 1917, Francis Picabia published the first number of his review *391* with Josep Dalmau. It was in the same gallery that Miró had his first and only exhibition in Barcelona, in March 1918: his works, however, proved disconcerting and not a single canvas was sold.

From July 1918 on, he was to stay for long periods at Mont-roig* in an isolation that allowed him to concentrate and meditate. There he

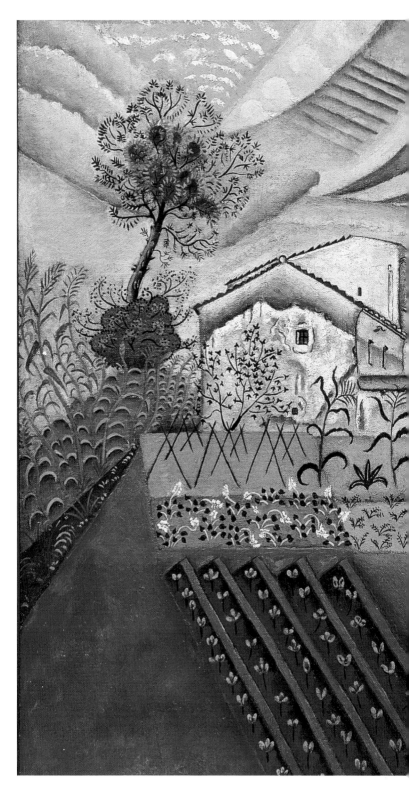

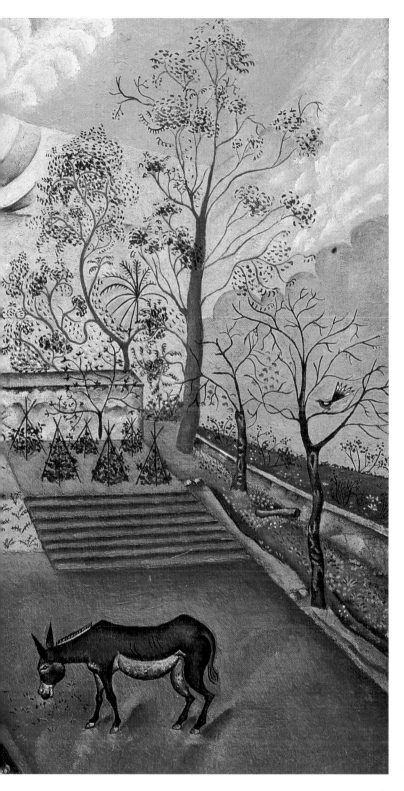

THE STORY OF MIRÓ

arrived at an idiosyncratic realism in which naturalistic details are minutely observed and scrupulously reproduced. Early in 1920, fired by intellectual curiosity, Miró traveled to Paris. There then began a prolonged period during which he alternated between reveling in the capital's social life and a desire to keep to himself, shut off from the rest of the world. His arrival in Paris in 1920 coincided with the eruption of Dada and with the crystallization of what was to become Surrealism*. For Miró the shock was a violent one and he spent three or four months suffering from artist's block.

This first spell in the French capital was difficult. He experienced genuine poverty but, thanks to Dalmau, he got to know all the writers of the modern generation, Pierre Reverdy and Max Jacob in particular. Come winter, he had moved to rue Blomet*, into a studio close to the one belonging to painter André Masson. This was a time of discovery and interchange, marked by the onset of lifelong friendships. Rue Blomet proved a magnet for Parisian intellectuals, becoming a meeting place for Michel Leiris, Antonin Artaud, Juan Gris, Robert Desnos, Louis Aragon, and, occasionally, André Breton and Paul Eluard. Between get-togethers at which the arguments would fly back and forth, Miró would take himself off to the Louvre or to the Musée du Luxembourg, where he was overwhelmed by what he saw. As summer approached, he returned to Spain dazed by all he had absorbed. In the Catalan countryside, still stunned by his Paris experiences and friends, he began to work "like a slave" (Rowell 60). "I had lost everything; it came back to me only on my return to Mont-roig the following summer, where all at once I literally burst into painting like a child bursts into sobs." In July 1920, he wrote to his friend E. C. Ricart: "Definitely never again Barcelona. Paris and the countryside until I die" (Rowell 73).

Paris was the place to be a painter, though Miró still needed to be grounded in the countryside. It was at this time that he completed *The Farm**. "*The Farm* was a résumé of my entire life in the country. I wanted to put everything I loved about the country into that canvas—from a huge tree to a tiny snail. I don't think it makes sense to give more importance to a mountain than an ant (but landscape artists just can't see that), and that's why I didn't hesitate to spend hours and hours making the ant come alive. During the nine months I was working on *The Farm* I was working seven or eight hours a day. I suffered terribly, horribly—like a condemned man. I wiped out a lot and started getting rid of all these foreign influences and getting in touch with Catalonia" (Rowell 93).

Miró unearthed new discoveries deep in the past. The earth crystallizes the Catalan heritage to which he would often allude: the mountains, the sun, the beaches, the architecture, and the folk art that he so loved for its instant impact and anonymity. He was impressed too by its Romanesque wall paintings and prehistoric sites. Mural art possesses a magic power that transcends any visual quality: Miró was fascinated by these cave paintings imbued with spirituality, mystery, and magic. At the end of the summer he returned to Paris, bringing his picture with him, hoping to sell it, but in vain. It was finally purchased in 1923 by Evan Shipman, an expatriate American writer and Ernest Hemingway's secretary. *The Farm* then passed to Hemingway.

Miró's pictures of the 1920s are structured like free-verse poems. Sometimes he would introduce "poem-sentences" into his canvases so as to organize them visually. He felt a strong affinity with contemporary poets and devoured their writings; they had a direct influence on his work. Miró read the precursors of Surrealism voraciously: Rimbaud, Jarry, Apollinaire, Lautréamont, and especially poetry in the tradition of Jarry's *Surmâle*. His reading gradually shepherded him away from the realism he had been practicing up to *The Farm*. There then started a phase in which he based his work on hallucinations: "At the time I was living on a few dried figs a day. I was too proud to ask my colleagues for help. Hunger was a great source of

Painting-poem
("Happiness
of Loving my
Brunette"),
1925,
oil on canvas,
36 ¼ × 28 ⅓ in.
(92 × 72 cm).
Private
collection.
Photo AKG.

these hallucinations. I would sit for long periods looking at the bare walls of the studio, trying to capture these shapes on paper or burlap." In 1924, he finished *Tilled Field**, a canvas which marks the onset of a prolonged personal rebellion. While starting out from reality, Miró now endeavors to sever all links with the world. His vision is of a new world, an interior reality that expresses the spirit, the heart of Montroig rather than any physical landscape. From now on, the guiding light in his work was to be the imagination, in parallel with Surrealist ideas that promote the imagination as a means of attaining true reality. He moved away from naturalism, transcending painting and creating a pictorial language made up of legions of signs and symbols.

In 1925, Miró made the all-important acquaintance of Jacques Viot, at the time director of the Galerie Pierre (i.e., Pierre Loeb) on rue Bonaparte. Viot took an enthusiastic interest in Miró's painting and became his dealer*, organizing a one-man show for him. The invitation was signed by the Surrealists and the event culminated in the painter's first major success. The same year, Miró embarked on a series that Rosalind Krauss and Margit Rowell call the *Magnetic Fields*. This title refers to the short collection published by André Breton and Philippe Soupault in 1920, which, according to Breton himself, was the "first Surrealist (and by no means Dada) book, since it is the outcome of the earliest systematic application of automatic writing." In this sequence of paintings Miró simplified his palette to monochrome blue, gold, sienna, and bister; on a partially transparent ground, he would trace very fine, fragile lines, as if he was trying to make them weightless and avoid interfering with the hovering space of the monochrome. His painting was no longer descriptive in any way: it possessed a value in itself, morphing into script, continuing along the path blazed by the series of drawings created in a hallucinatory state which had come to a head in *Harlequin's Carnival**.

This new way of looking at painting betrays many connections with automatic writing. Miró transcribes space, yet without creating an illusion of it: finding inspiration in the unconscious, these are dreamlike paintings executed with great spontaneity*. With extraordinary economy of means, he then went on to create visual images where the unbounded space recedes, where a fathomless depth filled with interlocking, hybrid forms evokes the plenitude of the cosmos. One of these paintings is *The Siesta**, in which embryonic shapes can be glimpsed floating in a blue field scratched in with the tip of the brush.

Between 1925 and 1927, Miró created a group of paintings whose compositions are inspired by Apollinaire's *Calligrammes*. These "painting-poems,"* among them *The body of my dark-haired woman because I love her like my pussycat dressed in salad green. . .* , herald a true visual revolution. At the same time, the painter often gave vent to the aggressiveness he felt welling up in him with pictures expressing violence, especially *The Sign of Death* and *Personage Throwing a Stone at a Bird*. During the summer of 1926 in Mont-roig, Miró felt these aggressive stimuli coming to a climax, and he determined to prepare an exhibition that would pack all "the shock of a punch." Hiding away in Paris, he continued painting, driving himself hard through the entire winter. Leaving rue Blomet for Montmartre, he moved into a studio his dealer Jacques Viot had managed to unearth on rue

Tourlaque. In what was for him a new district and a Surrealist haunt, he found himself living near Max Ernst, René Magritte, Paul Eluard, and Jean Arp, whose quest for the quintessence of things he shared. Back in Mont-roig in summer 1927, he painted several large canvases depicting landscapes near the village and was at last able to feel that the phase begun the preceding summer was drawing to a close. The resulting canvases he showed to Pierre Loeb who was to exhibit them at Bernheim's in 1928. The show was a success, almost a sellout. But the months of grueling effort had drained Miró; he felt bereft, empty to the core. As always, however, finishing one project merely spurred him on to begin another, to seek out an opportunity to ask new questions. He sought untrodden paths, moving towards those of the spirit, which contain the purest magic. For Miró, when he observed nature or some other object, always strove to go beyond the thing before him and reach out to the inner mystery within.

It was thus that the metamorphosis inaugurated by the *Dutch Interiors** began to take shape. Following a brief sojourn in Holland, Miró produced four canvases based on postcards he had bought on his travels. Distancing himself from the scenes reproduced, he

Personage Throwing a Stone at a Bird, 1926, oil on canvas, 17 × 36 ¼ in. (73.7 × 92.1 cm). Museum of Modern Art, New York. Photo AKG.

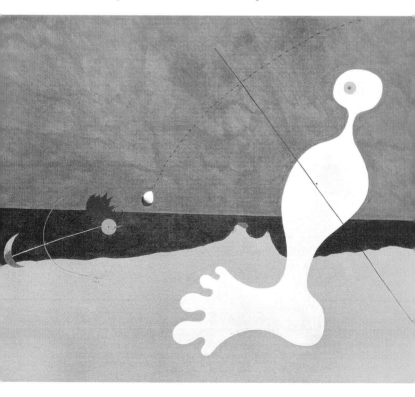

demonstrated the absurdity of mirroring reality with photographic fidelity, and evinced the hostility he now felt for the conventions of Western painting. These works can be envisaged as forerunners of a still more brutal reaction expressed in 1928 in his proclamation of "the assassination of painting*." For some time afterward, Miró was to forgo canvas and painting generally. During winter 1928–29, he turned instead to collage, in which objects and forms are thrown together by chance. In collages, he could tell stories and concoct imaginary portraits, such the *Spanish Dancer**. This newfound working method called into question the visual laws governing creativity. Every creation was a terrain on which his new visual poetry was being developed; he would constantly introduce picture postcards, completing the composition with drawings and reveling in the juxtaposition of differently textured surfaces.

Painting, 1933, oil on canvas, 40 ½ × 64 in. (130.3 × 162.5 cm). Fondació Joan Miró, Barcelona. Photo AKG.

In 1933, in his workshop on the Passage del Crédit in Barcelona (the attic of his boyhood home), he produced a series of large pictures that had their origins in engravings of tools, machines, and other implements. Miró used these reproductions to devise and

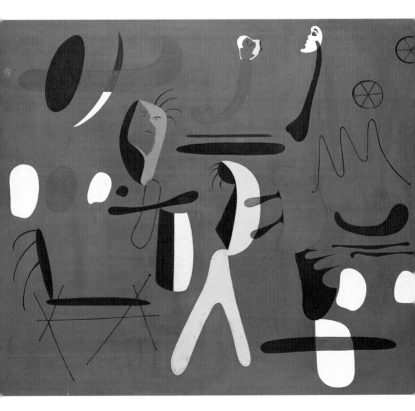

arrange compositions, before sticking them onto blank sheets of paper. The composition was subsequently explored as raw material for pictures: the machine motifs were thus transformed, morphed, into strange forms that float in space. Now unrecognizable, they lose all trace of their inspiration. Completely divorced from their starting point, pictures in this series, such as *Painting*, are like zones governed by a calligraphic or musical rhythm. As was his custom, once he had finished work on one series, Miró quickly headed for new pastures.

The atmosphere of the years 1934–35 was fraught: Miró launched into a series of pastels astonishing in their violence, color schemes, and formal distortion—initial stages in what his biographer Jacques Dupin was to dub his "wild" or "savage" paintings. These pastels were composed against the backdrop of a worsening political climate that greatly affected Miró. As artist and collector Roland Penrose has explained, his paintings of the time constitute a prophetic outburst against the horror about to engulf Spain in the Civil War. In *Man and Woman in Front of a Pile of Excrement*, the sky turns portentous and black. Against this sinister ground, a grotesque couple with overdeveloped sexual attributes stands out: the scene is otherworldly, terrifying.

Civil war proper broke out in July 1936. By the end of November, Miró, whose Republican sympathies were well known, found himself unable to return to Spain, and he remained an exile in Paris until 1939. His suffering and concern sought an outlet in *Still Life with an Old Shoe**, painted at the same time as Picasso's *Guernica*. With his wife and daughter in tow, Miró stayed first in a hotel room, then in an apartment, before settling near Varengeville-sur-Mer, Normandy, in the Clos des Sansonnets, close to the house of another painter he admired, Georges Braque. As the world around him became increasingly parlous, this natural retreat kept Miró out of the turmoil, and he entered a meditative phase. In these peaceful surroundings, he embarked on another significant series, the *Constellations**. Entirely different from his previous still lifes, these are canvases swarming with signs, with sometimes monstrous figures, and with stars that gather in constellations and cover the picture completely. The graphism that proliferates tends to make these pictures look alike. With the feeling that he was acting as it were covertly, and hence somehow escaping the tragedy around him, Miró turned to smaller formats. He was genuinely afraid of being prohibited from painting, as the Nazis had done with Emil Nolde. Thanks to a cultural attaché from the embassy he had met in Paris, however, Miró was permitted to send a certain number of his works (including *Constellations*) to the United States.

Two Women, 1935, oil on cardboard, 29 ½ × 39 ⅓ in. (75 × 105 cm).
Sprengel Museum, Hanover. Photo AKG.

Following page: *Metamorphosis*, 1936, collage and gouache on paper,
24 ¾ × 19 in. (63.5 × 48 cm). Private collection. Photo AKG.

A debut retrospective was organized at New York's MoMA in 1941, at a time when he was practically unknown in Europe, or at best treated as a hermetic artist appreciated solely in avant-garde and Surrealist circles.

Then bombs started raining down on Normandy. Forced to quit Varengeville, Miró returned with his family to Barcelona before settling in Palma de Mallorca where he stayed until 1942. The successive summers he spent in Mont-roig were to afford him an opportunity to take stock of the exile years during which he had lived from day to day and been forced to cut back production. It was only in 1944–45 that he was once again able to take up his brush. He now distanced himself from the pictorial agenda he had previously developed in the copious notes made during 1941 and 1942: he evidently concluded that his work had been moving in a direction different from that of his earlier thoughts.

The year 1944 saw the advent of the first glazed ceramic vases and plates that Miró produced in collaboration with his friend Llorens Artigas, together with small figures and bronze heads. In his painting, driven by an insatiable desire to purify his pictorial language, Miró was now mostly building up his compositions over broad, light-colored grounds. In this vein, he produced a sequence of fifty lithographs, the *Barcelona* series, that consolidated his attachment to a city to which he had at last been able to return and that reaffirmed his unwavering sense of Catalan identity.

In New York in 1946, the success of the *Constellations* exhibition in Pierre Matisse's gallery, hard on the heels of the splash made by Miró's retrospective at MoMA in 1941, undoubtedly had an impact on the self-questioning climate that took hold of the American art scene at the close of the war. Young artists were searching for fresh sources of inspiration, for ways of escaping from the outmoded dogmas of Cubism as much as from the voracious predominance of Picasso's genius. To them, Miró's poetic, unconstrained, "primal" oeuvre must have appeared as a viable alternative. In addition, the notable success of his shows had earned him a commission for a large-scale mural in the restaurant of the Terrace Piazza Hotel, Cincinnati. To fulfill it, the painter had to stay in New York from February to October 1947. There, he produced etchings and aquatints in engraver Stanley W. Hayter's Atelier 17, a meeting place and forcing ground for a whole generation of American painters, where they were initiated into techniques of gravure that were rarely practiced on that side of the Atlantic. In New York, Miró was also

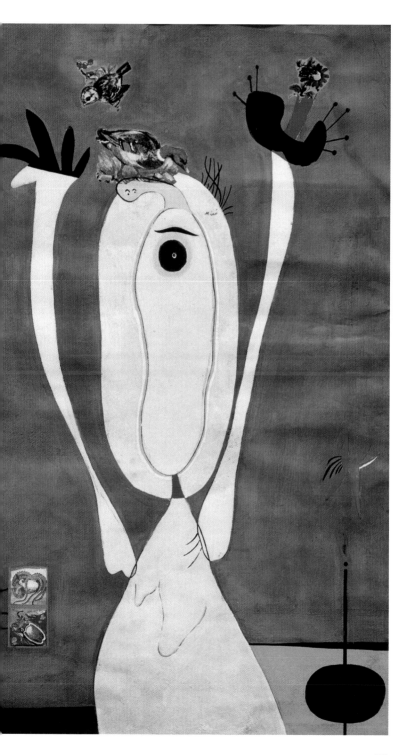

finally able to catch up with his friends from Paris: Alexander Calder, Marcel Duchamp, Yves Tanguy, and composer Edgar Varèse. Following the ground breaking text written in 1941 by James Johnson Sweeney for Miró's debut American retrospective, the publication in 1948 of a monograph by the famous American art historian Clement Greenberg set the seal on Miró's transatlantic fame. Moreover, this consecration had the fortunate side-effect of releasing the artist from the constant money worries that had beset him up to then.

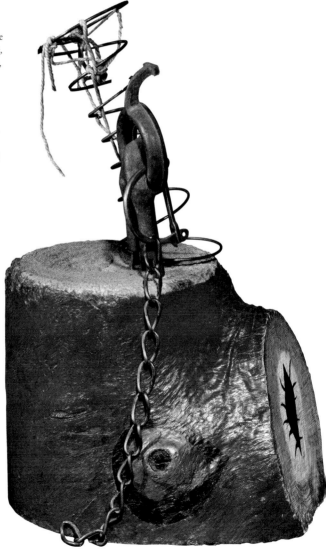

Object of Sunset , 1935–36, painted carob-tree stump, bedspring, gas burner, chain, manila string. Musée National d'Art Moderne, Centre Georges Pompidou, Paris. Photo CNAC/MNAM/ J. F. Tomasian.

After an eight-year absence, Miró returned to Paris for the exhibition *Surrealism in 1947* organized at the Maeght Gallery and curated by Duchamp, Breton, and the American architect Kiesler: the event signaled the return of the now sizable Surrealist camp following its enforced exile caused by the war. Through the poet Tristan Tzara*, Miró met Aimé Maeght who quickly became his main Parisian dealer: he in turn introduced him to the printer Fernand Mourlot, who was to produce a number of illustrated books and lithographs by Miró issued by the gallery. At the same period, his oeuvre was diversifying, as painstakingly composed works alternated with paintings produced briskly, spontaneously. He freely acknowledged he had been struck by the first "drippings" painted by the then young American artist Jackson Pollock (Miró had already come across him at Hayter's in 1947) exhibited for the first time in Paris at Studio Fachetti in 1952. Miró too started to paint more freely on large canvases employing a broader, more liquid technique.

Having purchased a plot of land in Majorca at the beginning of the 1950s, the painter asked a friend, Catalan architect Josep Lluis Sert, to build him the "large studio" he had dreamed of for so long at Son Abrines*: this new space, which he acquired definitively in 1956, was a contributing factor in the increasing size of his paintings, while simultaneously fostering his work on plans for sculptures* and, increasingly, prints* (this interest in lithographic processes earned him a Grand Prix for engraving at the 1954 Venice Biennale). In the area of ceramics*, a new phase of creativity commenced with a very intensive two years (1954–56) spent in Artigas' workshop at Gallifa, now with the assistance of the master's young son, Joan Gardy Artigas, who, at the end of Miró's life, was to play such a crucial role in realizing the late large-scale projects. Following earlier, passably tentative forays in 1944–45, this second session of collaboration resulted in more significant and demanding clay pieces (plates, vases, egg forms, pebbles, but above all sculptures of sometimes imposing dimensions), which were to be shown in the Galerie Maeght in 1956. The reaction of the public, unaccustomed to such a novel treatment of clay, was lukewarm. It is a remarkable fact that from 1956 to 1959 Miró produced no new paintings. He was catching his breath, weighing up his oeuvre to date. However, he had launched into a project for two large ceramic murals on the theme of the sun and the moon, commissioned for the new UNESCO building in Paris. This was Miró's very first venture in the area of monumental public art, though he was not slow to become involved again in similar activities. In 1959, at the time of another trip

to New York, for a second MoMA retrospective, he was awarded the Guggenheim Foundation's international prize for this work. In addition, he turned his hand to a substantial number of projects for lithograph illustrations, enlisting the help of the foremost technicians for the various engraving processes to which he had recourse. From 1957 on, he began making prints in Crommelynck and Dutrou's new workshop in Paris. He also regularly practiced in the new gravure and lithography studio run by Maeght, initially at Levallois, before relocating to rue Daguerre in Paris in 1966. 1958 witnessed a publishing event: eighty engravings on wood for a seminal work by Miró's friend Paul Eluard entitled *A toute épreuve**. This should be regarded as one of the most successful twentieth-century collaborations between an artist and a poet. By now, Miró's international reputation was firmly established: a monograph devoted to him in French with a text by Georges Ribemont-Dessaignes and accompanied by poems by Jacques Prévert was brought out by Maeght in 1956.

Major retrospectives were staged in Amsterdam, Brussels, and Basel, while the graphic work was shown at Krefeld, Berlin, Munich, Cologne, Hanover, and Hamburg. In 1961, a group of pictures painted since 1959 were exhibited at Maeght's; considering that the artist had not shown any paintings since 1953, this was an important

Joan Miró in the Cromalinc brothers' gallery in 1957. Photo Michel Sima/Rue des Archives.

occasion. In an interview given at this time in the review *L'Œil*, Miró refers to the self-imposed assessment he undertook in the wake of the move to Majorca. The unbridled liberty of the next cycle of paintings borrows generously from American influences, ranging from Informel through Tachism to graffiti: in them, the painter focused on concepts such as space, the void, and immobility. The first of the monochrome triptychs exhibited in the gallery, entitled *Blue I, II, III**, is a telling example that heralds a new approach to space.

By this time, Miró's ideas about art were being aired more publicly: in 1959, for instance, the art critic Yvon Taillandier published a lengthy interview in the journal *XXᵉ Siècle* (published at that time by Maeght) whose title reuses the painter's now famous statement: "I work like a gardener." In it, Miró provided a clear and detailed statement of his working methods, as well as noting the images that had made the greatest impact on him. In 1961 there appeared a sizable monograph written by Jacques Dupin that included a first catalog of the paintings; an updated version was reissued in 1993. It was nonetheless not until 1962 that Paris hosted an institutional retrospective of Miró's work, at the Musée National d'Art Moderne, at that time situated in the Palais de Tokyo. Other retrospectives were to follow in 1964–65, at the Kunsthaus in Zurich and the Tate Gallery, London.

Joan Miró in his studio at Palma de Mallorca in 1967. Photo Daniel Frasnay/AKG.

Further major monumental* art projects followed the UNESCO commission: aided by his collaborators, the architect Josep Lluis Sert and the ceramic artists the Artigas, father and son, he fulfilled a substantial commission of thirteen large-scale pieces for the Fondation Maeght at Saint-Paul-de-Vence: this "Miró Labyrinth" made up of sculptures (including the *Monumental Arch* and *The Pitchfork*) was completed in 1968 by an extensive ceramic mural. Yet perhaps the project of the time for which Miró felt the greatest fondness was his extraordinary homage to the Mediterranean, *Sea Goddess*, in 1966, this huge ceramic sculpture was lowered into an underwater cave off Juan-les-Pins and later brought back to the surface. It is currently on show at the Picasso Museum at Antibes.

That same year Miró traveled to Japan for a retrospective of his work in Tokyo. He took the opportunity to learn about calligraphy, a major influence on the cycles of paintings he then began: the canvas *May 68* provides a shining example of the newfound energy he drew from Far Eastern physical movement, from its mastery of tension and relaxation. Miró visited Japan for a second time in 1969 for the installation of a ceramic mural under the aegis of the International Exhibition of Osaka (re-erected following the event in the city's folk art museum). He also

Le Père Ubu, 1974, bronze. Private collection. Photo Bridgeman.

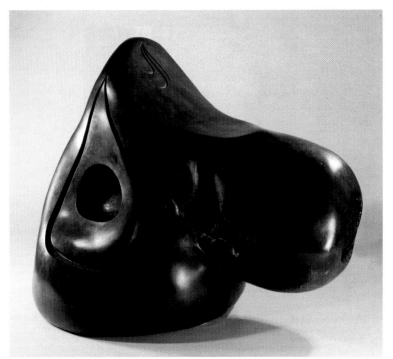

realized for Osaka 69 a group of monumental bronzes, *courges habitées* ("inhabited gourds"), and the so-called *capitipède* figures, all exhibited in the same hall at the Gas pavilion. A first retrospective-cum-exhibition devoted solely to the artist's sculpture was hosted by the Zurich Kunsthaus in 1972. Sculptures and ceramics were also shown at the Maeght Foundation* in 1973. But it was surely the panoramic exhibition entitled *Joan Miró, Magnetic Fields* in the Solomon R. Guggenheim Museum, New York, curated by Rosalind Krauss and Margit Rowell, that offered the most advanced perspective to date on the significance of his painted and sculpted oeuvre. In contrast, the 1974 exhibition at the Grand Palais in Paris, envisaged simultaneously as a retrospective and an opportunity to discover the most recent,

Woman, 1978, black and blue pastel on paper. Musée National d'Art Moderne, Centre Georges Pompidou, Paris. Photo CNAC/MNAM/ P. Migeat.

post-1972 cycles of paintings, received a mixed reception from critics. That same year, the corpus of engravings and illustrated books was shown at the Musée d'Art Moderne de la Ville de Paris, which was also to exhibit around a hundred sculptures in 1978. The painter's arrival in Paris at the beginning of the 1920s was commemorated by a bronze sculpture, *The Lunar Bird (L'Oiseau lunaire)*, set up on the site of his one-time address, 45, rue Blomet*.

Miró continued diversifying throughout the 1970s: in another first, he became involved in ballet* and was soon making sets and costumes. Taking inspiration from the artist's notebooks, Jacques Dupin wrote a synopsis of *L'Œil-oiseau* for him, a piece produced in 1968 by the Fondation Maeght and the Marseilles Opera Ballet company, later reprised for the 1982 Venice Biennale and in Florence. After 1972, Miró also tried his hand at textiles*, with the help of Josep Royo, a master weaver from Tarragona: the result was a far cry from traditional tapestry-work, Miró coining a term better suited to this new technique: *Sobreteixims*. He nonetheless found time to pursue his passionate affair with lithography, producing series after series of illustrations* for contemporary poets such as Leiris, Char, and Prévert. In 1973, the Catalan poet Joan Brossa wrote a text for him entitled *Oda a Joan Miró*, which the artist was to accompany with thirteen etchings and aquatints for publication. In parallel, Miró was working hard, erecting monumental murals, including the celebrated frontage of Barcelona's airport in 1970. Thanks to his donation to the State in 1975 of almost two hundred paintings, fifty sculptures, five thousand drawings, and the entire corpus of engravings, by 1976 the Joan Miró Foundation* in Barcelona (structured around a museographic program by his dealer there, Joan Prats) had become the focal point for Miró's reputation as a creative artist. In accordance with the artist's own request, the Foundation was also to find room for music, poetry, architecture, dance, and cinema, as well as international and Catalan contemporary art generally. In 1982, *Woman and Bird*, a monumental* sculpture seventy-five feet (24 m) tall, made of mosaic-covered cement, was (with the aid of Joan Gardy Artigas) set up in Barcelona in what is today the Joan Miró Park. This project marked the final homage the city was able to offer the genius of the artist while he was still alive: Joan Miró passed away on December 25, 1983. His wish for a Pilar and Joan Miró Foundation to be established on Majorca at the site of his "large studio" was respected; it has since been extended with a new exhibition building designed by Spanish architect Rafael Moneo and inaugurated in 1992.

Joan Miró on his 85th birthday in
his villa at Calamayor, in Palma
de Mallorca (September 11, 1978).
Photo Rue des Archives.

Gravures sur bois de

JOAN MIRÓ

A toute épreuve (woodcuts)

A toute épreuve ("Unfailing") surely constitutes the greatest twentieth-century example of a collaboration between a poet, Paul Eluard, a painter, Joan Miró, and a publisher, the Genevan Gerald Cramer. Since the beginning of the 1920s, Eluard had been an enthusiastic admirer and stalwart defender of Miró's art. *A toute épreuve*—a poem illustrated with eighty woodcuts—marks the materialization (as the title indicates) of this "unwavering" friendship. As it took form in March 1947, Miró saw the project as an opportunity to reinvent the traditional concept of the illustrated book. His ambition was to accompany the text step by step, to turn it into an almost musical "visual poem." As a benchmark, he took Stéphane Mallarmé's celebrated free-verse *Un Coup de dés...*, though he also much admired Gauguin's renowned woodcut illustrations. As the technique presents fewer difficulties than copper-plate engraving, Miró was able to express himself with great naturalness and simplicity. "To make woodcuts that arise from the *veins* in the wood"—this was his obsession. He also made ample use of types of paper different from those used to print the poem, cutting them out and gluing them, and even incorporating printed chromolithographs. Miró could thus mirror the rhythmical disposition of the sequences of the poem: sometimes the beat of the visual component accelerates; at others, he introduces a hiatus that lets the image breathe. First published in 1930, the poem *A toute épreuve* was reissued with Miró's illustrations on 25 March, 1958, in a run of 130 copies. Eluard, however, was never to see for himself the perfect osmosis his words and Miró's pictorial idiom had created: he died in 1952.

Abstraction

When asked his opinion of abstraction, Miró's reply would often be vehement. On occasion he would voice disgust for this type of art: "I cannot understand and take it as an insult to be placed in the category of 'abstract' painters" (Rowell 151). In 1932, when, in reaction to Surrealism*, the Abstraction-Création group was forming, Miró was invited to join. The artist demurred, however: "And they ask me into their deserted house, as if the marks I put on a canvas did not correspond to a concrete representation of my mind, did not possess a profound reality, were not a part of the real itself!" (Rowell 150–1).

Miró reproached those who took part in the movement with viewing abstraction as an end in itself. In 1951, he expounded on these views in the *Correo Literario* during discussions with the Catalan art historian and critic Rafael Santos Torroella: "This is not the way to spiritual freedom. You don't even gain a centimeter of freedom from art that's governed by cold formulas. You only get your freedom from art by sweating for it, by an inner struggling" (Rowell 226).

Miró himself was committed to never reusing a formula.

Illustration for the text *A toute épreuve*, by Paul Eluard, 1958, color woodcut. Photo AKG.

His own work is not linear: instead, it oscillates back and forth between plenitude and void. At certain periods, signs and figures invade the space frenetically, while at others (or sometimes simultaneously) the sound of monochrome clouds is sufficient to bring the painting into existence. Miró was inclined to simplify line and color. But even when a canvas verges on the abstract, the title will give hints as to its narrative subject. Miró's paintings are anchored in reality, in what he could observe around him, or in what he dredged up from the unconscious. In the 1960s, however, Miró appeared to abandon the magic spells of signs and adopted a clarity that aimed instead at creating a feeling of space. He moved away from figuration and edged towards pure abstraction, as witness his 1961 triptych *Blue I, II, III**. Abstraction, so violently rejected in the past, reached its apogee with the 1968 triptych *Paintings on White Background for the Cell in Solitary I, II, III** and *The Hope of a Condemned Man*, 1974.

Drop of Water on the Pink Snow, 1968, oil on canvas, 76 ¾ × 51 ½ in. (195 × 130 cm). Private collection.

■ AMERICAN PAINTING (MIRÓ'S INFLUENCE ON)

In the post-war era, many young painters instantly grasped the profound originality of Miró's oeuvre. The text accompanying Miró's first retrospective at the Museum of Modern Art, New York, in 1941, was read avidly by all those who sought to escape from the strictures of Cubism and the all-pervasive influence of Picasso: to such artists, Miró's organic universe was a model worth exploring. In Barbara Rose's eyes, Miró's "writing" undoubtedly furthered the stylistic evolution of painters such as Gorky, Gottlieb, de Kooning, Rauschenberg, and Cornell and more undeniably still, Pollock. According to Rose, Miró was one of the main catalysts, perhaps the only one, for Pollock freeing himself from Picasso and from the Mexican muralists who since 1941 had dominated his work. She also refers to the influence of the landscapes and

Jackson Pollock, *Untitled*, c 1942–44.
Scottish National Gallery of Modern Art,
Edinburgh.

seascapes Miró had produced in 1927 on the immense stretches of color Mark Rothko began painting in 1950 (the celebrated "Color Field" paintings in which the only pictorial event is a horizon). But the painter who most explicitly recognized the debt he owed to Miró's art was Robert Motherwell: the use of black in the "Elegies for the Spanish Republic" series is directly taken from Miró's ideograms. Meanwhile, as early as 1948, the great theorist of post-war American art, Clement Greenberg, wrote one of the first monographs of significance on Miró, a text which did much to make the innovative and unusual components of his art more widely known in the U.S. In turn, Miró was a keen observer of the American avant-garde scene, particularly during his second stay in New York in 1959. On that occasion, he derived renewed creative energies that were to rejuvenate the art of his last years—for instance, in the great tripartite murals of the 1960s that are imbued with a savage lack of restraint and with an unparalleled, almost ferocious vitality of gesture.

■ Artigas

The Catalan ceramist Llorens Artigas (1892–1980) met Miró at the Sant Lluc Academy in 1917. They were to encounter one another again in the Agrupacio Courbet, a gathering of young artists who were rebelling against tradition and academism. In 1918, Artigas was one of the very first to write about Miró's painting; in 1923, it was he who lent Miró the studio on rue Blomet in Paris where he worked for several years. The artistic paths of the two friends soon diverged, however, and their first artistic collaboration actually dates only from 1944. By then, Artigas was a consummate ceramist with a rigorous, first-rate oeuvre to his credit. One of his peculiarities was to reject electric or gas furnaces as well as industrial glazes and clays: Artigas preferred to concoct his glazes for himself, while he built a Korean-style wood-burning kiln that he used for high firing, whose progress he could closely monitor. The extraordinary ease with which Artigas treated the elements of his art may be compared to the methods and discipline Miró followed in painting as he sought to master his creative processes. When he started working with Artigas, he pleaded with him: "You don't have to become Miró: I, Miró, have to become a potter." Miró's monumental ceramic murals benefited a great deal from their unshakable artistic alliance. After the death of his friend, Miró realized his last great mural and urban projects in ceramics with his son Joan Gardy Artigas (born 1938), who had been assisting his father since 1953: the walls in the IBM Corporation building in Barcelona (1976) and the Palace of Congress in Madrid in 1979. In 1992, it was Gardy Artigas alone who composed the ceramic wall for the café in the Miró Foundation in Palma de Mallorca, basing his work on a design by Miró.

Painting-object, 1931, white oil paint and sand on wooden plank stapled to wire-mesh. Musée National d'Art Moderne, Centre Georges Pompidou, Paris. Photo CNAC/MNAM/ Jacques Faujour.

■ Assassination of painting (The)

In the course of a discussion with Tériade published in the arts pages of *L'Intransigeant,* Miró mentioned what he called the "assassination of painting." After the groundbreaking works of 1925, he began to call his painting practice into question and felt impelled to extend its limits. He threw off the realism of *The Farm* and began drawing instead the results of the hallucinations he was experiencing due to lack of food. His paintings were now executed with incredible spontaneity* in accordance with a method close to the "automatic writing" being developed by the Surrealists. In about 1927–28 Miró's commitment to transcending painting culminated in the creation of "picture-poems" that owed much to Apollinaire's poetic *Calligrammes.* Miró subsequently gave up painting completely for a time in order to concentrate on collage, an activity involving combinations of all manner of incongruous elements. In these "picture-objects," he sought to shock the viewer with objects gleaned from trashcans or thrown up by the sea, juxtaposing them with the basest materials.

In 1931, he declared to the Madrid journalist Francisco Melgar: "Painting revolts me; I can't bear to look at my work. I haven't got any at home: I won't even let my wife hang any of these things on our walls"

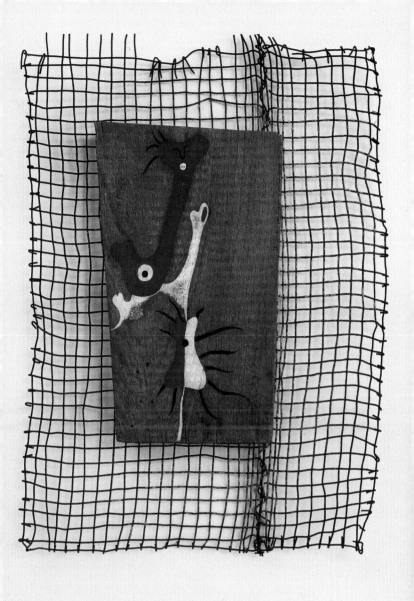

(Rowell 117). The outbreak of war brought a brief pause. Around 1941, though, Miró once again succumbed to the pleasures of painting in the *Constellations** series. Yet this too proved a short respite, since he was soon dreaming of escaping from the traditional format of the gallery- or museum-bound painting to reach a broader public by means of vast, unconventional formats. He thus switched to mural works in ceramics. The influence of the new American painting also gained in intensity and Miró granted an increasing role to gesture. He was consequently to virtually abandon the easel to paint on the ground lying flat on his front, or else on trestles, dipping his fingers or fist in the color to draw: Miró "murdered" easel painting the better to immerse himself in paint.

Available art

For Miró, diversity of media and materials was a means of touching the widest possible audience. In a text printed in the May 1938 number of *XXe siècle* entitled, "Je rêve d'un grand atelier" ("I dream of a large studio"), Miró explains: "I would like to try my hand at sculpture, at pottery, engraving, and to have a press, to try also, inasmuch as possible, to go beyond easel painting, which in my opinion, has a narrow goal, and to bring myself closer, through painting, to the human masses I have never stopped thinking about" (Rowell 162). At a later date, the artist voiced his considered opinion of conventional art: "Easel painting is something experimental. Valid research in itself, no doubt, but laboratory research; you have to go through it, but it should really lead to greater things." Miró strove to outgrow the individualist phase represented by easel work and practice an anonymous, collective art. His murals, he felt, should be informed by the architecture, the plan, and the environment, and thus ensure the total fusion of each ingredient. Likewise, ceramics, created in collaboration with specialized craftsmen, is collective, and dictated to a still greater degree by its materials. Miró dreamt "of the advent of an era of purely collective artistic production." The prominence he attached to these two parameters, the collective and the anonymous, was echoed by his interest in popular art, of which he collected large quantities and which constituted an unquenchable source of inspiration for his sculpture. It was this collective standpoint that led Miró to become interested in

the staging of ballet*, since this was an artistic activity through which he might maintain direct contact with the public.

Ballet

For Miró, a canvas offers musical and poetic rhythm. He makes no distinctions between poet, musician, and painter. In consequence, he became interested in staging ballets, events which would put him into direct contact with the public. In April 1926, together with Max Ernst, he had worked for the Ballets Russes on the sets for *Romeo and Juliet*. At the time of the performance in Paris, at the Théâtre Sarah Bernhardt, the Surrealists whipped up a furore, voicing their disapproval of Ernst and Miró's collaboration on what they termed an "eminently capitalist" venture. The brouhaha, however, merely guaranteed the show's success. A few years later, in 1932, Boris Kochno asked Miró to make designs for the curtain, costumes, and dancers' accessories for another ballet to be produced by the Ballets Russes, *Jeux d'enfants*. The choreographer, Léonide Massine, with whom he was to work for many months, saw Miró's art as closely related to choreography: "The extraordinary, extemporized forms, their persuasiveness, as much in terms of line as volume, both complement and enhance the movements taking place against the backdrop. . . . When one's eye alights on the coordination of the colors and the forms in his pictures, one is filled with involuntary joy, a need to dance." Later, in 1976, Miró collaborated with La Claca, a troupe of Catalan players headed by Joan Baixas, for whom he designed costumes and sets for a play, *Mori el*

Sketch for the costumes for *Jeux d'Enfants*, 1932. Private collection. Photo Bridgeman.

Merma. For the first time, in a piece inspired by his undying admiration for Jarry's *Ubu Roi**, he also made contributions to the scriptwriting. Miró designed a series of enormous dolls in the tradition of carnival figures or of those village processions with giant puppets, the whole ensemble being directed by a grotesque "Père Ubu." Although they were banned from performing under Franco, it was Miró who brought La Claca back to their native Catalonia with this savage and provocative play that parodied middle-class values, not without veiled allusions to the Generalissimo. Together with Picasso, Miró never accepted the status quo under Franco, and it remained of supreme importance for him to make a stand as a defender of Catalonia.

■ BLUE I, II, III

The dreamscapes of 1925 had already shown Miró's desire to lose himself in space. By the time of the triptych *Blue* painted in 1961, this need had become still more imperative. Miró gave up the interplay of signs and symbols to plunge into the infinity of color. The misty blue, an unbounded space, is occupied by black spots and traces of red. A line crosses *Blue I*, to reappear, still more majestic, in *Blue III*. The first canvas in the triptych shows a constellation of eight black blobs that dissolve into the blueness. On the left, a halo of fire diffuses outward from a red dot; a fragile line crosses the canvas, stopping a moment before tailing off to allow the air to flow. The same line pulls the eye toward the right, toward *Blue II* where the spots are orchestrated with greater rigor. The vertical stroke of red, lengthening out, creates further dynamism; all seems organized. The horizontal series of the black "pebbles"—shown in more intense detail and more saturated color—throws a bridge over to *Blue III*. The final canvas is the emptiest. Like string on a kite, the line seems to quiver with every wisp of air. Its red tip pulls the viewer out into the depths of cosmic space. To this soothing and gigantic surface—the three pictures in total measure more than thirty feet (10 m) in length—Miró imparts a spiritual dimension: "It took me a long time to do them. Not painting them; meditating on them. It required enormous effort, extreme inner tension, to attain the sparseness I was aiming for. The preliminary stage was intellectual in nature. . . . It was like before the celebration of a religious rite, yes, it was like taking religious orders." When, following lengthy, concentrated contemplation, Miró began at last to paint, he paid the closest attention to his every move: the ground is laid in with the movements the wrist imparts to the brush—every breath of the hand matters.

Blue I, Blue II, Blue III, triptych, oil on canvas, each panel: 106 ⅓ × 139 ¾ in. (270 × 355 cm).
Musée National d'Art Moderne, Centre Georges Pompidou, Paris.
Photo CNAC/MNAM/Bertrand Prevost.

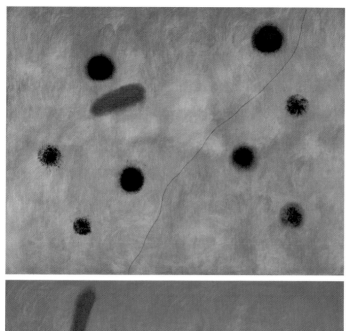

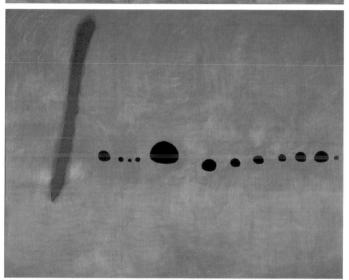

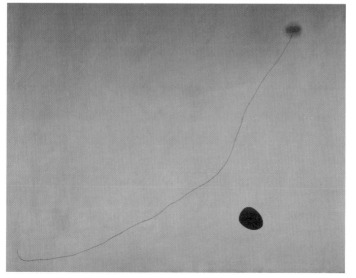

41

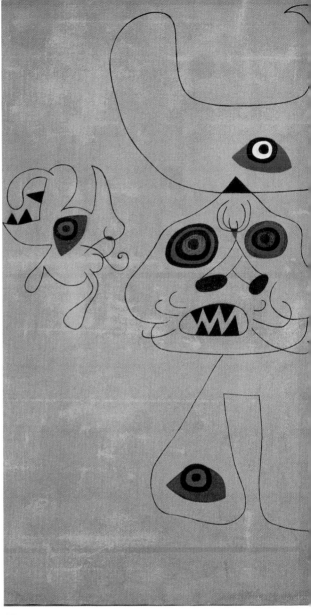

The Bullfight,
October 8, 1945,
oil on canvas,
45 × 57 ½ in.
(114 × 146 cm).
Musée National
d'Art Moderne,
Centre Georges
Pompidou, Paris.
Photo
CNAC/MNAM/
Adam Rzepka.

■ Bullfight (The)

In 1945, Miró painted some large-scale canvases which combine shapes in motion and shapes at rest over a light-hued ground. He was now devoting his time to exploring movement and in *The Bullfight* he deploys—within the overarching rhythm of the composition—dynamic signs that animate the central subject. In the *Catalan Notebooks** one finds a sequence of annotations and drawings that translate Miró's impromptu reflections on bullfighting, the subject of a series of canvases that he rubbed down with sandpaper to give them a feeling of *matiere*. Miró turns the gestures and actions he observed into imagery. As he notes: "There are also fans spread out like little suns or rainbows. . . . The spectators

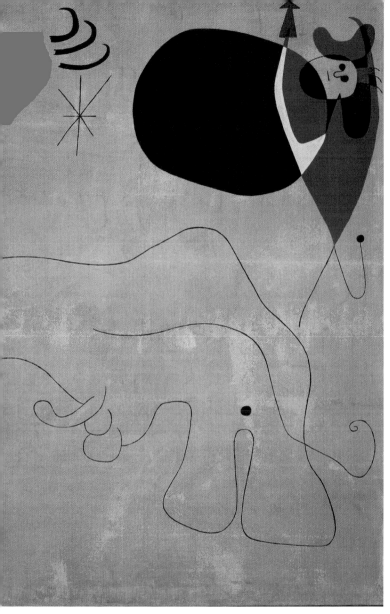

beat as a single heart; put a large heart in the canvas. . . . The *banderilleros* are like multicolored dragonflies/little stars, little suns, and rainbows emerge from the horse's blood. . . . Also, place a handwritten mark in the space standing for the swallow's shrill call." These notes morph into a swirl of symbolic signs that float in the picture space: the center is taken up by a substantial line drawing. The bull—dense, muscular, thickset—is thus represented as transparent: the heavy envelope of the body has vaporized, leaving behind only the animal's spirit. Its crazed eyes, ferocious jaws, and flaring nostrils hark back to its battle with the toreador, a tiny figure in black and red who ascends into the sky in the direction of the blue arrow.

▪ CALLIGRAPHY

In canvases of 1925–27, Miró exactingly transcribes the movement of his writing hand in bold strokes. This writing, however, remains subordinate to the painting. As his biographer Jacques Dupin has noted, the words count little and the meaning still less than the letters, which are treated as marks living a life of their own. For Miró, the letter was indicative of a force—just like the visual signs (stars, moons, spots, hybrid forms) that comprised his pictorial vocabulary: he gradually started to paint as he would write, and soon he was writing as he painted. From the time of *Swallow Love (Hirondelle Amour)*, this once serene and unassuming script was to undergo a mutation; here, the movement of each isolated word conforms more harmoniously to the figures which now seem to embrace the overall rhythm more expansively.

The influence of his travels in Japan and of Eastern calligraphy proved far-reaching in Miró's postwar oeuvre. In 1964, for the library at St. Gallen, Switzerland, he was to execute a long, narrow mural that can be interpreted as fragments or read as a single, unbroken sentence traced in thick black lines typical of Japanese *makimono*. "I work more and more in a trance," he confided. "I consider my painting as increasingly one of gesture." The canvas entitled *The Song of the Vowels*, 1966, composed in a free calligraphic style over an unusually tall, narrow format, provides a further example patently inspired by Japanese scrolls: "I feel a deep affinity with the Japanese mind." In an interview in 1970, the artist explained to Margit Rowell that seeing work by Japanese calligraphers during his stay in Japan in 1966 influenced his technique considerably and brought it closer to the Zen aesthetic informed by a paradoxical relationship between motion and immobility of forms in space, by the tension and relaxation of the creative gesture—exemplary themes in Miró's work as it applies to the space of the canvas or wall.

Women, Bird and Water Drops in the Night, 1944, Indian ink, watercolor, and gouache on loose canvas over stretcher, 45 ½ × 36 ⅔ in. (114.5 × 88 cm). Private collection. Photo AKG.

■ Catalan identity

"We Catalans believe you must always plant your feet firmly on the ground if you want to be able to jump in the air. The fact that I come down to earth from time to time makes it possible for me to jump higher" (Rowell 211). This is Miró's explanation of the cyclical impulses of an oeuvre that seemed to him to be dictated by his background and by a fondness for the country of his birth. The artist stressed: "I am Catalan," and went on to make the forceful assertion that: "The Catalan character is not like that of Malaga or other parts of Spain. It is very much down-to-earth" (Rowell 211). The swipe at Picasso is overt, and the art critic George Charbonnier, in a 1951 interview, is not wrong when he states that the viewer often feels that a Picasso canvas is dramatic, while a picture by Miró tends instead to arouse humor. Miró concurs, if laconically: "That's Catalonia." From the very beginning of the 1920s, Miró's painting derived its stimulus from the Catalan countryside (as in *The Farm* or in *Vines and Olive Trees*). This influence, however, seems more insistent still in ceramics and sculpture: Miró was always keen to make the latter reflect Catalonia's mountain landscape and integrate into it seamlessly. As late as the 1970s, his prints continue to express the Catalan temperament: the *Gaudi* series takes as its starting-point some shards from the broken mosaics in the Parc Güell in Barcelona. In the same spirit, Miró produced a sequence of engravings entitled *Les Rupestres* directly inspired by the prehistoric caves at Altamira. At the end of his career, his attachment to

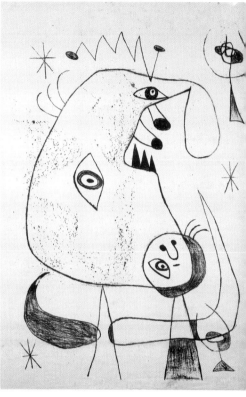

Illustration from the *Barcelona* series 1939–44, lithograph. Fondació Joan Miró, Barcelona. Photo Bridgeman.

Catalonia remained much in evidence: 1973 saw a set of thirteen etchings and aquatints entitled *Barcelona*, as well as the ten etchings and aquatints in the series *Mallorca*. These series give expression to the emotional balance Miró maintained with respect to the two cities, one from his father's and the other from his mother's side—two places of paramount importance to his life and art.

■ Catalan Notebooks

The *Catalan Notebooks* cast valuable light on the artist's creative processes. On every page the editor, Gaëtan Picon, lets us relive the conversations he had with Miró in the studio on Majorca as they searched through hundreds of drawings,

sheets from sketch- or note-books, objects, pebbles—a treasure trove that constituted, as Picon put it, Miró's "booty." "On each sheet of paper he had noted the year and the day, sometimes the hour. And yet these lines all float about on the same restless surface. Time? He liked to say that time doesn't count: 'I belong to daylight.' Dating is not meant to measure distance, to attest to progress—rather it serves to keep track of this ceaseless activity: at every instant, there's always *that*." A form noted on a given day and left to its own devices causes a shock when encountered much later. Subsequently reworked, it can engender new forms. "I squirrel them away like seeds. Some germinate, others not. I need them to work away in my brain, as if outside me: waiting is still work; sleeping is work. I just put petrol in the tank, that's all. Like the child in its mother's womb: that's how it develops." Gaëtan Picon—on pages that accompany reproductions of drawings, leaves from notebooks, torn sheets of paper, and a few paintings—interprets the visual signs he observes. His commentary is periodically interrupted by personal reflections by Miró that throw light on his working practices. Here one dives deep into a secret world, the one that precedes, that generates the pictures. By examining these *Catalan Notebooks*, one acquires a profound insight into what lies, invisible, in the images.

Relief plaque, 1956, ceramic. Private collection. Photo Bridgeman.

CERAMICS

During the initial stage (1944–46) of Miró's collaboration in the workshop of ceramist Llorens Artigas in Barcelona, the artist executed ten large vases and many decorative plaques. Artigas made the blanks—turned on the wheel or worked on the slab—while Miró painted the surfaces with colors prepared by the potter. The most inventive works of the period are the acid and glaze paintings he made on broken fragments of refractory clay from a disused kiln. The discovery of these materials he could paint on both sides led him to cease working on the slab. Miró's primary interest focused on how such techniques might affect his habitual practice as regards line, color, and material: attending carefully to the mixture, he broadened his personal vocabulary, even going so far as to deliberately deteriorate the glazes in the kiln: "The material must be respected. . . the material. . . determines what is to be done. It imposes its laws" (Rowell 218). Firing in the kiln agglutinates the figures in the material-cum-paint, making the artist's early results resemble the prehistoric cave paintings he admired so much. In a notebook dated 1948 headed, "From the assassination of painting to ceramics," he evokes, through verses in the form of a *calligramme* in the style of Apollinaire, his exhilarating discovery of the transformation of earth by fire. Mentally, and in communication with the potter, Miró worked long and hard in preparation for the second ceramic period in 1954–55. He was now intent on tackling the forms himself directly. At this time, Artigas left Barcelona to set up a

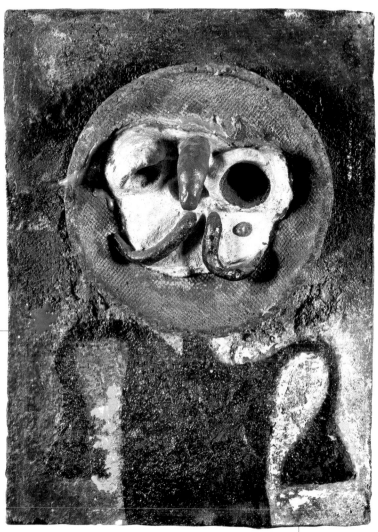

workshop and kiln in a tiny mountain village called Gallifa. There Miró painted a great number of pebbles and produced a series of eggs. Over time, he had become sufficiently skillful to be able to juggle a sense of humor and a spirit of protest, as in the *Antiplats,* where relief sabotages function. Large sculptures too were born, comprising natural objects (calabash, tree branches, rocks) which became metaphors for sleeping and dreaming, for sex, or for birth and intrauterine life. Between 1954 and 1956, 232 pieces were to be fired in some 80 batches. Some of the most beautiful were to be shown at the Galerie Maeght in 1958, provoking surprise and consternation among a public unaccustomed to such freedom in the treatment of pottery.

■ CONSTELLATIONS

Executed in 1940 and 1941, the complete series of *Constellations* comprises twenty-three small gouaches and oils on paper of identical format, fifteen by eighteen inches (38 x 46 cm), or vice versa depending on the position on the page. Miró had embarked on this new departure in his career in Varengeville, Normandy, where he was to stay from 1939 until the German army invaded France. He produced ten pieces in this small village, then a further ten in Palma, with the final three being painted in Montroig. The war aroused in Miró a desire for escape: far from the epicenter of the conflict, a magical inner world burst forth. He later explained the genesis of these *Constellations*: "It happened like this. In Paris I had bought a pad for cleaning my brushes. The first time I used it, I was amazed by the results. After that, whenever I finished one of the *Constellations* I would clean my brushes on a clean sheet of paper which provided a ground for the next one" (Rowell 295). The series had roots too in music and nature. Miró comments that: "the night, music, and the stars began to play a major role in suggesting my paintings. Music had always appealed to me, and now music in this period began to take on the role poetry had played in the early 'twenties—especially Bach and Mozart when I went back to Majorca after the fall of France" (Rowell 209). In Palma the previous year, he would regularly visit the cathedral to hear the organ and remembers Kandinsky telling him that he too would draw listening to music. The *Constellations* are a world in motion, one populated with

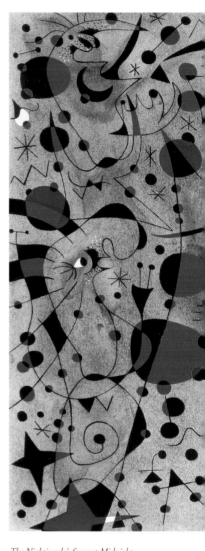

The Nightingale's Song at Midnight and Morning Rain,
1940, gouache and oil wash on paper. Private collection. Photo Bridgeman.

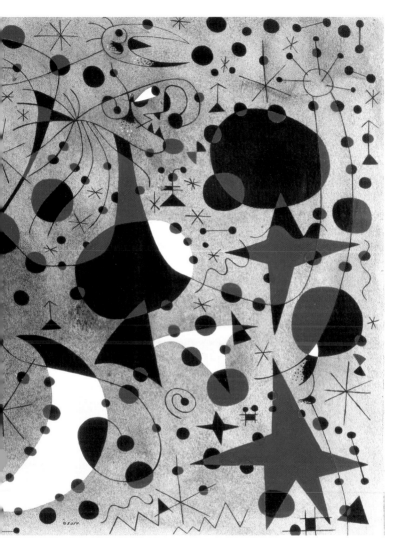

bizarre animals with aggressive features, filled with stars, circles, and other geometrical forms, interpenetrating and self-generating incessantly. The line invades the surface, crossing back and forth, intersecting, never breaking. As the series progresses, there are drawings filled with black, red, or blue which create a balance between filled and empty zones, bestowing a musical rhythm on the whole. These representations of the cosmos are accompanied by highly poetic, storybook titles, such as *Woman at the Edge of a Lake Whose Surface is Turned iridescent by a passing swan* or *The Nightingale's Song at Midnight and Morning Rain*. For Miró, only poetry subsists amid the tragedy that engulfs him.

Joan Miró
in the Cromalinc
brothers' gallery
in 1957.
Photo Michel
Sima/Rue des
Archives.

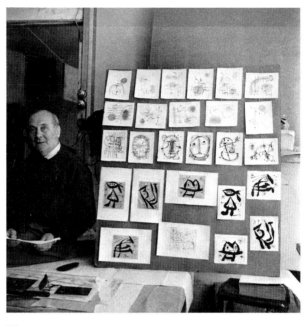

▨ Cycles

At the conclusion of a conversation with the art critic Yvon Taillandier transcribed under a title taken from Miró's famous dictum, "Je travaille comme un jardinier" ("I work like a gardener"), appearing in 1959 in the journal *XX^e Siècle* (subsequently republished in 1963 by Adrien Maeght), the artist stated that his inspiration is governed by alternating cycles: "The same process makes me look for the noise hidden in silence, the movement in immobility, life in inanimate things, infinity in the finite, forms in a void, and myself in anonymity" (Rowell 253). Miró confesses to working through contradictory impulses, one work often coming into being as a reaction to another. Indeed it is noticeable that calm or austere pictures are frequently succeeded by garishly colorful or animated images. The first type is dominated by the void and by

gesture; in the second, the space ends up saturated with motifs and figures.

Miró's diverse contacts with the Surrealist movement during the 1920s probably had a tumultuous effect on his painting, urging him to purify his work and so leave it more open to the imagination, as in the 1925–29 series of *Landscapes and Portraits* such as, for example, *Photograph: This Is the Color of My Dreams**.

Thereafter, Miró reverted to a figurative representation of reality and to the compulsive accumulation of objects in two dimensions and in the conception of his sculptures. He acknowledged the bipolar nature of his personality, and he sought to justify the opposing currents of humor and tragedy in his work: "I might look calm, but underneath I am a tormented soul. Surrealism opened a universe that justified and soothed my torment" (Rowell 275).

Dealers (Jacques Viot, Pierre Loeb, Pierre Matisse, and Aimé Maeght)

Throughout his career, Miró enjoyed the devoted loyalty of several notable art dealers. The first of these was Jacques Viot. He ran the gallery Pierre Loeb had opened not long before on rue Bonaparte where, in 1925, he was to put on an exhibition of new work by Miró. The invitation bore the name of the Surrealists and the event was staged in the turbulent atmosphere of the movement. Jacques Viot remembers the guests' amazement as they gazed at these astonishing canvases for the first time, and attempted in vain to connect them to the elegant and polished figure of the painter. Miró expressed his fondness for Viot in an interview published in *La Publicitat* in 1928: "I still admire him because he's the only man I have ever known who has really risked anything in life. I don't think there's anything very heroic about being my dealer today" (Rowell 95). From the year of Miró's exhibition onwards, Pierre Loeb, convinced of the artist's talent, also defended his work. In 1928, Loeb organized a Miró exhibition at the prestigious Galerie Bernheim, on rue du Faubourg Saint-Honoré, which showed the fourteen large canvases the artist had painted between 1926 and 1927. Miró was soon on friendly terms with Loeb, who put on further exhibitions for him. A third figure of prime importance, Pierre Matisse, became at once a faithful companion and an exemplary dealer. After 1932, he frequently showed Miró's work in New York and did much to advance his reputation. After the war, the United States was the first country to fully appreciate the painter's significance, partly due to Matisse's championing. In lithography especially, Miró received support from Aimé Maeght, himself a one-time draftsman lithographer passionate about gravure and illustration, who was to exhibit Miró's work regularly from the turn of the 1950s on. This collaboration grew still closer after Aimé and Marguerite Maeght set up their Foundation* at Saint-Paul-de-Vence.

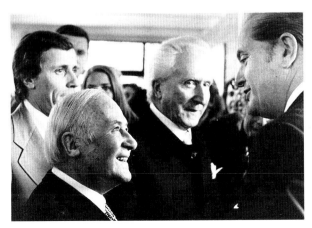

Joan Miró and Aimé Maeght, April 17, 1973, at Saint-Paul-de-Vence. Photo Rue des Archives.

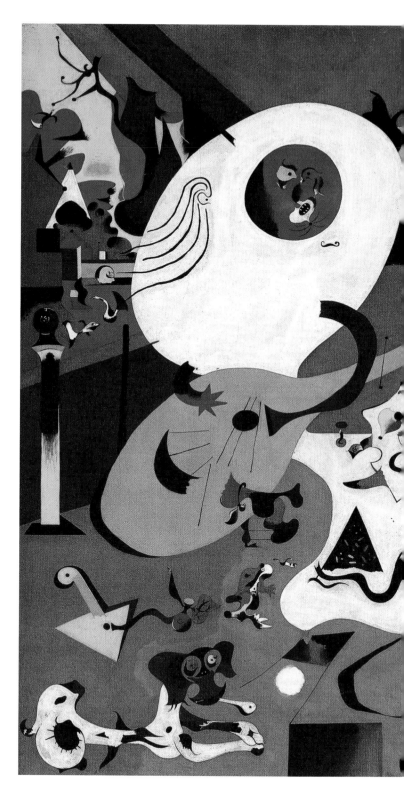

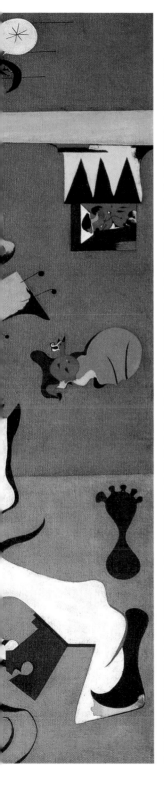

■ Dutch Interior I

In spring 1928, Miró made an excursion to the Netherlands. His experience of seventeenth-century Dutch genre painting, which transcribes everyday reality in tireless detail, induced him to reflect on the capacity of art to depict the real. The result was the series of five pictures, *Dutch Interior I, II, and III, The Potato,* and *Still Life with Lamp. Dutch Interior I* is the reinterpretation of a work by H. M. Sorgh, *The Lute Player* (1661), which Miró painted on his return to Paris using a postcard of the picture as a starting-point. One can recognize the shape of a musician holding his instrument, the window opening on to a landscape beyond to the left, the dog in the foreground, the cat to the right, as well as the picture hanging at the back of the room. The general atmosphere is a far cry from the original, however. Once again, Miró has started out with a real scene only to create a fantastical image that swarms with imaginary creatures. The painter here reverts to strong colors, juxtaposing flat tints of yellow, violet, green, dark brown, and white. Signs taken from the vocabulary Miró elaborated in the 1920s are clearly discernible, namely the footprint, the flyaway hair, the moustache, the insects and birds: the calm of the Dutch scene has yielded to agitation and a musical rhythm. The series of *Dutch Interiors* was followed by a group of four pictures, the *Imaginary Portraits,* painted by Miró at the beginning of 1929 in his studio on rue Tournaque, also after reproductions of pictures in museums, though here the style is noticeably less dense.

Dutch Interior I (after Hendrick Maertensz Sorgh, *The Luteplayer*), 1928, oil on canvas, 36 ¼ × 28 ¾ in. (92 × 73 cm). Museum of Modern Art, New York. Mrs. Simon Guggenheim Fund.

■ FARM (THE)

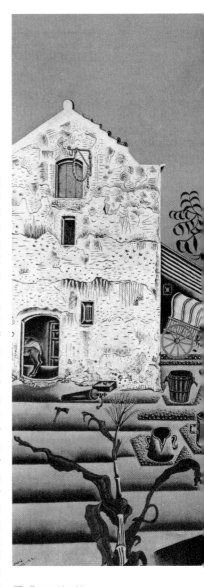

The Farm, 1921–22,
oil on canvas, 52 × 57 ¾ in. (132 × 147 cm)
National Gallery of Art, Washington.

Once back in Mont-roig in summer 1921, Miró embarked on a landmark picture, *The Farm*. Following the exhibition at the Delmau galleries, he began a new chapter in his career that Dupin has called "poetic realism." In a move away from the spontaneous, rhythmical chromatic accents of his early work, Miró here launches into a precise and detailed delineation of the family farm at Mont-roig and its countryside activities. This meticulous study is shot through with a love for the colors of the Catalan landscape that also can be seen in pictures such as *Vegetable Garden with Donkey* , or *The Tileworks*. Certain specific scenes are anchored in a sense of everyday reality—in particular, a woman doing her laundry, or the horse raising water from the well in the distance. There's a dog barking, an upturned bucket, a watering-can—a microcosm in which each painstakingly delineated element is carefully arranged in a homogeneous composition. Visual equilibrium is ensured by the repetition of certain motifs, such as the sun, with a foil in the murky form of a hole planted with a huge eucalyptus tree, and echoed too by the colorful circle denoting the trough on the right as well as by the carriage wheel on the left. The stylization of the leaves on the tree is achieved with an economy of means that recalls the treatment of nature in Venetian

painting at the turn of the sixteenth century. One thinks in particular of Giovanni Bellini, whose depictions are imbued with the same strain of spiritual concentration that runs through Miró's work. This perceptive eye is also reminiscent of the spiritual relationship that Far Eastern, in particular Japanese, artists entertain with nature. Miró's intention is to attain the "happiness given by managing to give due weight to a blade of grass in a landscape; why should it be disparaged?—that blade of grass, as beautiful as any tree or mountain." It is this spiritual dimension that allows the artist to distance himself from what he sees. Miró has no hesitation in distorting the scale of the objects, such as the scrap of newspaper in the foreground; in this way, he conveys an inner vision of a landscape—a vision that veers from the real to the fantastical.

■ Giants (The)

Starting in 1957 and in conjunction with the team around Robert Dutrou, a printer-engraver in Paris, Miró was to execute prints for work by the poets René Crevel and René Char. Miró hated starting on a pristine surface: he preferred some previously prepared support that for him could be like an old, stain-spattered wall. He might, for instance, apply to the plate a crackle glaze so as to render the exposed surface more irregular and thus more receptive. He could also draw lines with unconventional implements—a fork, for example. In 1960, he brought out a sequence of copper plates measuring almost three feet across which had been randomly punctured with holes before engraving. The six black and white aquatints known as the *Series of the Giants* look like a succession of violent indentations, but in fact represent a group of yelling "warrior" figures. These are rendered by briskly applied, broad strokes that drew upon the artist's entire physical strength. This gallery of gesticulating phantoms foreshadows later compositions Miró carried out using carborundum. Starting in 1967, Robert Dutrou was to initiate the artist into this novel

Sheet from the *Giants* series, 1960, aquatint, 23 ½ × 36 ¼ in. (59 × 92 cm).

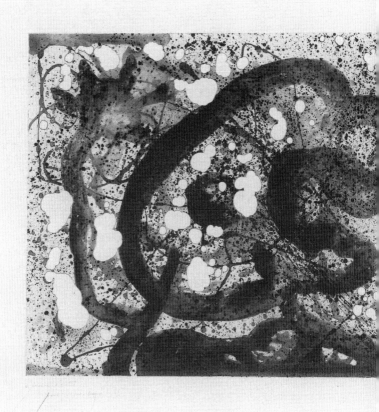

technique, developed by the painter Henri Goetz, in which intaglio is replaced by a relief engraving raised on a resistant layer covering the copper surface. Employing this process, Miró was able to carry out what Jacques Dupin dubs "gravure-pictures," monumental works as much in terms of sheer size as in the power and depth with which they translate the artist's gestures. Here too we meet a group of primitive anti-portraits erupting in black humor and dramatic intensity: black dominates over a white or color ground, with fluid contrasts and remarkable breaks in the substance.

◼ Gold of the Azure (The)

In the 1960s, Miró began simplifying his vocabulary of signs and symbols: it became less dense and more of the canvas was left empty. Though gaining in concision, his compositions nevertheless accorded an important role to drawing. Lines remain remarkably precise: the curve that runs horizontally through *The Gold of the Azure*, for instance, stretches imperturbably over nearly six feet (1.75 m). This picture informs a transitional phase in Miró's oeuvre. In what is a conscious contrast, the painter juxtaposes the fragile calligraphy of the stars and the horizon with a new departure, a dense, powerful black line—the direct result of the artist's gesture—which will predominate in works of the following year such as *The Poet's Words* or *Dance of Figures and Birds*. Miró works on the canvas, building up a complex impression of depth out of a succession of strata. The fragile marks designating the stars, the red dot and the density of the dark spots on the cloudy, golden ground produce different levels of depth suggestive of infinite space. In this void filled with hovering astral bodies, one is suddenly struck by the limitless depth of the blue. Indicated by the white aureole, an abyssal sky emerges through a rip in the bank of gilded clouds. Apart from the graphical rendering of the stars, the picture has shaken off all links with concrete reality: Miró stands on the verge of abandoning every trace of figurative representation and of escaping into unbounded cosmic space. If, until then, he bestowed narrative titles on his canvases which for him

Following double page: *Gold of the Azure*, 1967, oil on canvas, 80 ¾ × 68 ⅓ in. (205 × 173.5 cm). Fondació Joan Miró, Barcelona.

amounted to "an exact reality" designed to accompany the decipherment and interpretation of the signs and symbols, *The Gold of the Azure* has no story to tell. This is not a narrative image: it immerses us instead in the abstraction of meditation.

■ Hands Flying off Toward Constellations

Around 1955, taking time off from the UNESCO building, Miró and Artigas traveled to Santillana del Mar to gaze at the famous cave paintings at Altamira and "to meditate before the earliest mural art in the world." Miró had always been an admirer of this anonymous art whose power remains undimmed by the centuries. He respected this form of primitive expression that predated the acceptance of pictorial conventions from which he was constantly trying to escape—as testified by this canvas splashed with jets of paint that seem to spurt out of the picture space. In the 1970s, Miró would lay a canvas on the floor, pour liquid paint over it, lift it up, and then, once the colors had run as he desired, lay it back down flat. Such masterly lack of constraint marks a complete break with previous practice. For Miró, such renewal was imperative: "I painted these pictures in a real frenzy, with a real violence so that people would know that I am alive, that I breathe, that there are still many paths left for me to explore." In *Hands Flying off Toward Constellations*, Miró assigns pride of place to gesture and to physical contact with the painting. No words appear, no writing. Moreover, the painter no longer utilizes a brush, but attacks the surface with his

hands in an immediate, instinctual manner. The format of this vast, elongated canvas, eight and a half feet by twenty-two feet (2.61 × 6.80 m) and the spontaneity* of the gestures imprinted upon it recall prehistoric cave art and, like it, provoke a jolt to the senses, an emotional shock that is scarcely less potent. *Hands Flying off Toward Constellations*— expressing once again an unquenchable desire to escape from reality.

■ **Harlequin's Carnival**

Miró painted *Harlequin's Carnival* in rue Blomet*. As in *Tilled Field** the previous year, imagination reigns supreme. In this canvas the artist combines an attention to detail with an extraordinary wealth of invention. He conjures up a strange universe that swarms with weird creatures seemingly floating, weightless, in space. As in *Catalan Landscape/The Hunter,* 1923–24, the background is partitioned into two colors,

Harlequin's Carnival, 1924–25, oil on canvas, 26 × 36 ⅔ in. (66 × 93 cm). Albright-Knox Art Gallery, Buffalo. Photo AKG.

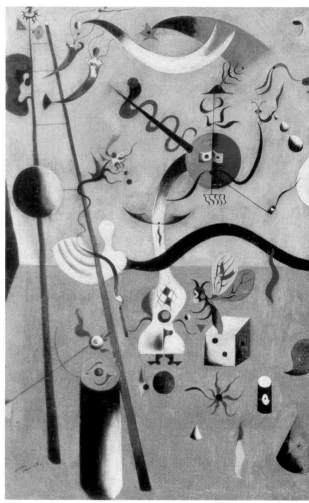

evoking the separation between earth and sky; the deep blue of the heavens can just be glimpsed through the window. The giant ear, which already features in *Tilled Field*, is this time affixed to the side of an unsteady-looking ladder* that inclines towards the solar disk. The motif of the solitary eye also reappears, lying, perhaps displayed, on a plinth. The shooting star, some musical notation, and the luminous blue all conspire to evoke a buoyant and playful atmosphere through which a fantastical bestiary blithely drifts. The delicacy and richness of every detail requires attentive decoding, as in a poem. Miró himself encouraged such comparisons: "For the *Carnaval d'Arlequin*, I did many drawings based on the hallucinations brought on by my hunger. I would come home at night without having eaten and put down my feelings on paper. I saw a lot of the poets that year, because I thought it was necessary to go beyond the

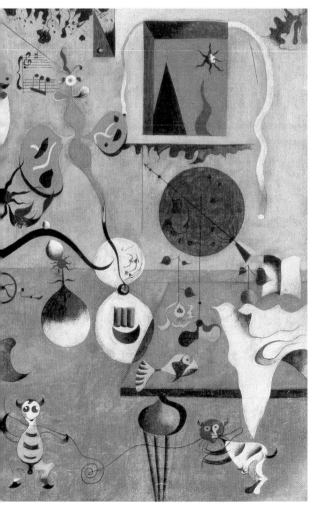

'plastic fact' and arrive at poetry" (Rowell 161). The narrative density of the picture was the inspiration for a text by Miró published in *Verve* in 1939 whose words and visual images recall, as Margit Rowell has pointed out, the poems Robert Desnos and Benjamin Péret were writing in the 1920s, also sometimes under hypnosis. The state of mind shared by both text and picture have affinities with the ideas of Surrealism*, which holds that, paradoxically, imagination provides the surest road to the real. In the event, the *Carnival of Harlequin* was to be exhibited at the Galerie Pierre in an exhibition of Surrealist painting that also showed works by Picasso and Klee. This picture marks the end of a brief but extremely inventive period during which Miró developed an astounding language of forms.

▨ Humor

"If there is something humorous in my painting, it's not that I've consciously looked for it. Perhaps this humor comes from a need to escape from the tragic side of my temperament. . . . In the same way, my painting can be considered humorous and even lighthearted, even though I am tragic" (Rowell 247, 253). This lucid admission of an ambivalent psyche provides a rationale for Miró's deliberate adoption of humor and fantasy in his oeuvre. Vast numbers of works pulsate with an idiosyncratic, high-spirited, effervescent, child-like, almost schoolboy

humor. Even though dramatic meaning might be deduced from the titles, even if the female figures can on occasion turn violent (*Woman in Revolt* or *Women Armed with Sickles*, 1938), the tension is always released by a look in the eyes or a comic gesture. Miró marshaled his efforts to make the famous *Spanish Dancer* of 1941 "cruelly comic and biting" and the "humor particularly grating," as grotesque and as slapstick as a "Mère Ubu*." He strove, particularly in his canvases of the 1940s, to alloy humor with poetry, "just as in Jarry," of whose literary work he was a self-confessed devotee. Patently, his starting-point remains gripped by ferocity and by a tragic sense of existence: "By nature, I'm pessimistic, so when I work I want to escape from this pessimism." Though he ridicules humankind, a "marionette" that should never be taken too seriously, he embraces the life-giving optimism that percolates through so many of his pictures—and still more, perhaps, in his sculptures. In 1974, the art critic Yvon Taillandier coined the perfect term to characterize the swarm of monstrous creatures ("huge heads with lines beneath that are legs") that overrun Miró's canvases and prints, and which seem to come to life more hilariously still in his ceramics and bronzes: looking flabbergasted or insolent, they are "*Capitipèdes*"—"heads with feet," from the Latin *caput* (head) and *pes* (foot).

Painting, 1953, oil on canvas, 76 ¾ × 38 ¼ in. (195 × 97 cm). Private collection. Photo AKG.

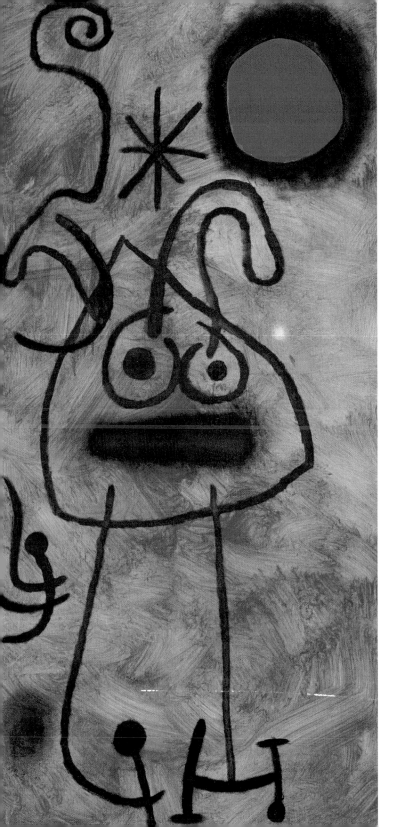

■ ILLUSTRATION

Illustration from *L'Enfance d'Ubu,*
Editions Tériade, Paris, 1975, color
lithograph on laid *velin d'Arches* paper.
Musée National d'Art Moderne,
Centre Georges Pompidou, Paris.
Photo CNAC/MNAM/Philippe Migeal.

Miró's time in the studio at 45, rue Blomet in Paris (1921–27) was a key period in that he met many great poets. It was there he encountered Robert Desnos, André Breton, Paul Eluard, and Jacques Prévert, to name but a few. Correspondences between Prévert's fantastical yet idiomatic oeuvre and Miró's art are clear. For a long time, the poet cherished the idea of collaborating with the painter on a full-scale book project: it was only in 1975, however, that this wish was to be realized when Miró illuminated a handwritten text Prévert had given him, *Les Adonides*, a composition that resembled a song of life and death. In his collection based on the manuscript, Miró mixed drypoint, etching, and aquatint: the outcome was forty-five engravings that to a certain extent constitute a "parallel writing" that Jacques Dupin characterizes as "an

engraved version of [Prévert's] text." A long-time close friend of the painter André Masson, the writer and poet Michel Leiris was also on good terms with Miró by October 1922 and they were subsequently to meet or write to each other frequently. These ties eventually led to Miró's illustrating a book composed jointly with Leiris entitled *Bagatelles végétales* which came out in 1956. Later, another sequence of poems by Leiris, *Fissures*, published in 1969, was accompanied by fifteen etchings. Artistic collaboration between Miró and the poet René Char was equally frequent: in his illustrations to a text by the poet entitled *Flux de l'aimant* (published by Adrien Maeght in 1975), the painter opted for drypoint. In 1976, he produced a further twenty-six prints in etching and aquatint to illuminate a lengthy, enigmatic piece by the same poet, *Le marteau sans maître*.

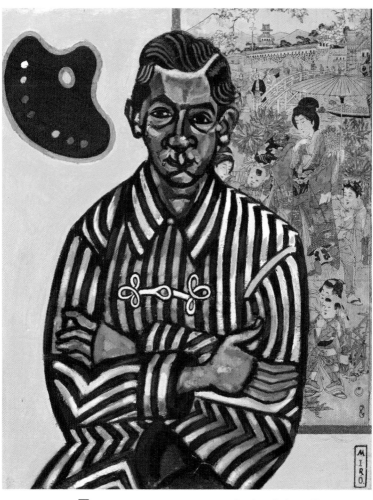

Portrait of Enric Cristòfol Ricart, 1917, oil and print glued to canvas, 31 ⅞ × 25 ⅝ in. (81 × 65 cm). Metropolitan Museum of Art, New York. Photo Scala.

◼ Japan

Miró felt a singular affinity with Japanese painters and calligraphers. The ships anchored off Barcelona that had returned from the Far East were laden with prints and other objects. Miró thus soon came in contact with the aspects of Japanese culture already widely available in Europe: on the lemon-yellow ground to the right in a portrait of E. C. Ricart (1917) he even glued a Japanese print. This recalls Manet's *Portrait of Emile Zola* (1867–68) and, more closely still, the *Self-Portrait with Bandaged Ear* by van Gogh (1889), whose expressive brushwork and coloring it emulates. In the portrait by Miró, however, unlike the two preceding *japonisant* portraits, a real print is actually stuck on the canvas. Occupying practically half the space, it is no longer a motif relegated to the rear of the picture. Beyond the attraction he felt for an art originating in a remote culture, Miró's predilection for Japanese culture is betrayed by his attention to and respect for

nature in its minutest aspects. In reference to something as insignificant as a tuft of grass, Miró wrote: "Apart from the primitives and the Japanese, almost everyone overlooks this which is so divine. Everyone looks for and paints only the huge masses of trees, of mountains, without hearing the music of blades of grass, of little flowers, and without paying attention to stones in a ravine—enchanting" (Rowell 57). In 1966, on the occasion of a retrospective staged by the museums of modern art in Tokyo and Kyoto, he finally traveled to Japan, and he was to return for the Osaka International Exhibition in 1970—visits that all made a profound emotional impact. He felt a passionate fondness for Japanese calligraphy, and its influence on his work is palpable. In the 1970s, indeed, Miró would often work in a trance-like state and considered his painting as increasingly gestural. Furthermore, just like his counterparts in the Far East, Miró believed that painting and poetry were one and the same thing.

■ Joan Miró Foundation (Fondació Joan Miró, Barcelona)

It was in 1968, on the occasion of the exhibition organized by the Barcelona city hall to commemorate his seventy-fifth birthday, that the idea of a foundation for Miró's art was first floated. It was approved by the artist, with the proviso that it should also become a center for the living arts, stimulating creativity among the young and increasing public awareness of the major movements of twentieth-century art. The plans for the building were drawn by Josep Lluis Sert, a friend of Miró's since the World's Fair of 1937 when they had worked together on the pavilion for the Spanish Republic. He was also to plan Miró's studio on Majorca as well as the Maeght Foundation* at Saint-Paul-de-Vence. Sert proposed a structure open to the outside that would integrate well into the landscape. The thorny question of interior lighting was resolved by the provision of skylights

View of the Miró Foundation in Barcelona. Architect: Josep Lluis Sert.

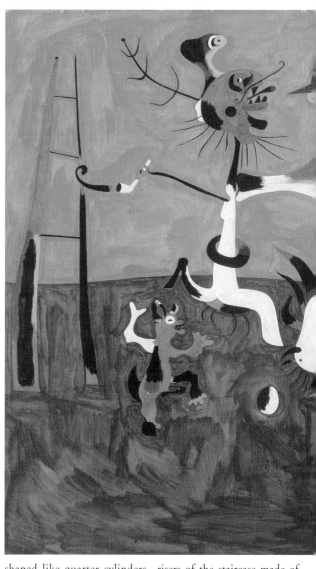

The Farmers' Meal, 1935, oil on cardboard, 29 ½ × 41 ¾ in. (75 × 106 cm). Private collection. Photo Bridgeman.

shaped like quarter-cylinders through which the daylight could penetrate, reflect, and finally descend perpendicularly into the building. The circulation plan focuses visitor flow on the patio and the accesses to the garden, while the materials employed are typical of Mediterranean vernacular architecture. The reinforced concrete was treated to turn it white, while the interior walls were rendered with white limewash; the tiles are red, the risers of the staircase made of wood. An octagonal tower houses an auditorium, a room for works on paper, and a library. Almost all the Miró holdings were donated by the artist himself, their most notable feature being a collection of almost five thousand pieces that A. Cirici has termed "the Miró papers." Drawings, sketches, and diverse annotations—together these collections constitute a priceless tool for any

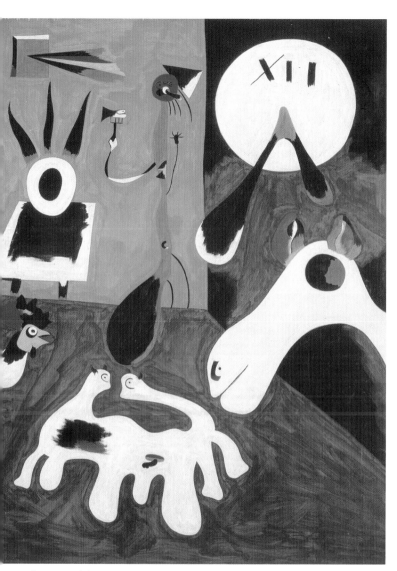

exploration of the artist's ideas and means of expression. The Foundation opened its doors in 1975. Ten years later, the space was enlarged in keeping with the original design by a disciple of Sert's, Jaume Freixa.

Ladder

The ladder is a recurrent motif in Miró's work. It surfaces for the first time in *The Farm** (1921–22), before reappearing regularly, drawn in a realistic or occasionally more diagrammatic manner—sometimes strongly present and highly colored, at others in just a faint outline. In *The Hunter* (1923–24), it is small in size and floats in space. Elsewhere, in *Harlequin's Carnival* (1924–25), it stretches up to the summit of the picture. It points heavenwards in *Dog Barking at the Moon*, 1926, and reaches the stars. Though sketched in a wavering line, the undemonstrative example in *Landscape with Rooster*, 1927, still ascends into

an infinite sky, while in *Nocturne near the Lake*, 1942, it hovers in fathomless space. Weightless, it is an ethereal symbol; Miró's economy of gesture has pared it down to two vertical and three horizontal strokes that terminate in little balls. The list of works in which this motif features might be extended indefinitely. A ladder leads us beyond painting; with each step as we ascend, we climb into the unknown, towards a higher realm; the ladder sets us free from the material world so we can attain the lofty sphere of the spirit. During the war, the ladder took on a symbolic charge, conveying the idea of escape. For Miró the motif was to change in meaning as his career progressed: "At the beginning, it was essentially plastic in form, only to become poetic later. Or perhaps plastic at the beginning, then nostalgic at the time of *The Farm*, then, finally, symbolic." In point of fact, the ladder materializes that craving for the absolute and desire for the infinite so explicit in Miró's works. In the 1970s, he would enter into a trance-like state before taking up his brush: this need to escape the sublunary world and transcend reality is perfectly epitomized in the ladder.

Head of a Catalan Peasant, 1925, pencil and oil on canvas, 36 ¼ × 28 ¾ in. (92 × 73 cm). Scottish National Gallery of Modern Art, Edinburgh. Photo Bridgeman.

▇ Landscapes and portraits: An economy of means

"[M]y painting no longer showed the pull of gravity; I wanted to give it an astral quality" (Rowell 265), Miró declared to art critic Denys Chevalier in 1962 as they walked around his first Paris retrospective staged at the Musée National d'Art Moderne (then located in the Palais de Tokyo). The critic underscores the "singular quality of absence" in the landscapes and portraits of the period 1926–29 that are centered entirely on the imagination. This phase corresponds to the artist's profound desire for clarity, for sparseness that is related to a need to attain maximum intensity through a minimum of means. Referring to the drive to destroy its own signs expressed in Miró's oeuvre, Chevalier speaks of what he calls his "pictorial Jansenism." Miró himself said he wanted "to smash the Cubists' guitar," i.e., break with the dominant schemas of construction. "My tendency to concision, to simplification," he explained, "applies to three areas: modeling, color, and the depiction of the figures." By around 1940, modeling and chiaroscuro have effectively been suppressed: "Without modeling or chiaroscuro, the depth has no limits; movement can carry on ad infinitum." In the same way, Miró now employed only a stripped-down range of forms and colors, an allusion to the austerity of the tenth-century Romanesque frescos he so admired. Increasingly, he rejected anything "picturesque" or too personal, striving to attain an anonymity and universality he hoped would be as primal, as overwhelming as the mural art in the Altamira caves.

It is also almost certain that the books he read encouraged him to pack still greater tension into his pictorial universe. Margit Rowell detects, for instance, the influence of Nicaraguan poet Ruben Dario in the evolution of the famous series entitled *Blue I, II, III** (1961).

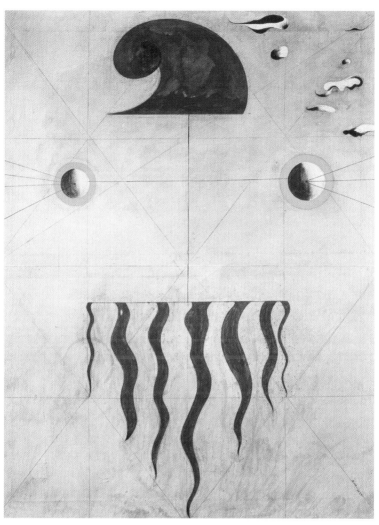

According to her, reading a text entitled "Azul" may have had a decisive impact on the magnificently uncluttered grounds of the painter's work: "It required enormous effort," Miró confessed, "extreme inner tension, to attain the sparseness I had in mind. The preliminary stage was intellectual in nature. . . . It was like before the celebration of a religious rite, yes, it was like taking religious orders."

■ Literature and poetry

"I make no distinctions between painting and poetry." Miró's esteem for poets was such that he even wrote in one of his notebooks that he intended "to live with the dignity of a poet." Immersing himself in poetry was one of the methods by which the artist combated what he called "painting-painting" whose representational presuppositions he shunned. By the same

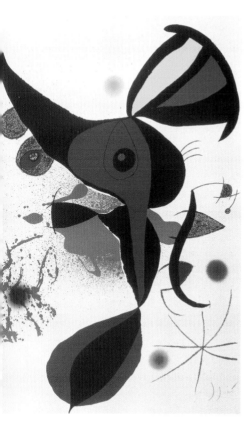

Ode to Joan Miró,
1973, lithograph.
Private collection.

poets of the twentieth century: André Breton, Paul Eluard, Michel Leiris, Raymond Queneau, Jacques Prévert, Antonin Artaud, René Char. He became associated with this exalted avant-garde circle through fellow-painter André Masson around 1922: "The poets Masson introduced me to interested me more than the painters I had met in Paris. I was carried away with enthusiasm for the novel ideas they brought and especially the poetry they discussed. I gorged myself on it all night long—poetry principally in the tradition of Jarry's *Sûrmalè*" (Rowell 208).

Miró was also interested in texts by contemporary Catalan poets, especially Foix and Joan Brossa. Keen to rescue Brossa's poetic oeuvre from neglect, in 1962 the Barcelona art dealer Gaspar commissioned Miró to provide illustrations for a text entitled *Cop de poma*; Tapiès designed the cover with Miró engraving an etching and four variants. In 1973, the same poet wrote an "Oda a Joan Miró" that the painter accompanied by nine lithographs of large dimensions. Texts from fifteenth-century Catalonia, presented under the title *Lapidari* by his great friend, the poet Pere Gimpferrer, proved to be the last book Miró illustrated (published by Maeght in 1981): a heartfelt testimony of the artist's attachment to the Catalan literary heritage.

token, he regarded poetry as an inexhaustible source of revitalized imagery and creative energy. He devoured it, his pleasure being all the greater when what he read was volcanic or radical. In his quest for a constant state of mental tension, however, he also admired the great mystics. When asked in 1951: "Who are your favorite poets?" he replied: "The Castilian mystics, John of the Cross and Teresa of Avila." This contrasts with the Surrealist and pre-Surrealist poetry that had inspired him in the years 1920 to 1930, a period in which the people he met and the friendships he struck up propelled him into the orbit of some of the greatest French

■ Maeght Foundation (Fondation Maeght, Saint-Paul-de-Vence)

Following a visit to the studio at Calamayor near Son Abrines*, Adrien Maeght resolved to entrust the con-

struction of the buildings and the planning of the exterior spaces for his own Foundation to Miró's architect Josep Lluis Sert. For Miró he set aside a terraced garden, and some walls and pools, as well as a tower with breathtaking views. The artist enlisted the help of the Artigases*, father and son, to help realize the sculptures and large-scale ceramics that were to be scattered about the Mediterranean landscape. In total freedom, these pieces, executed in various materials—ceramic, marble, bronze, iron, and concrete, accompanied by apparently completely heterogeneous objects and elements—fit harmoniously into the composition of what amounts to a "garden labyrinth." Towering over the countryside around the town stands a huge *Pitchfork*—an outsized version of the pitchfork used by Catalan peasants—in perfect equilibrium, like a signal. Opposite this natural arena, Miró set up a colossal arch on to which he grafted threatening-looking biomorphic forms. Made of concrete, its texture, encrusted with colored stones, is treated to look as thick as elephant hide. An enormous lizard crawls over a stone wall, bearing its circular, white-masked face on its back facing the visitor. The burbling of some brightly colored gargoyles, spewing out water, can be heard. Further on, immutable, disconcerting, stands an imposing black ceramic goddess; a notch made in her back holds a white leaf whose veins are reminiscent of the human spinal column.

Walking through the *Labyrinth*, one is first surprised, then enchanted, and finally amused by a world of strange, highly evocative figures whose strength as visual objects succeeds in blending in gracefully with a setting that itself exerts enormous power.

The *Labyrinth*: *The Pitchfork*, 1963, soldered metal, 199 ⅔ × 179 ½ in. (507 × 455.9 cm). *Disk*, 1973, ceramics, diameter 122 in. (310 cm). Fondation Maeght, Saint-Paul-de-Vence.

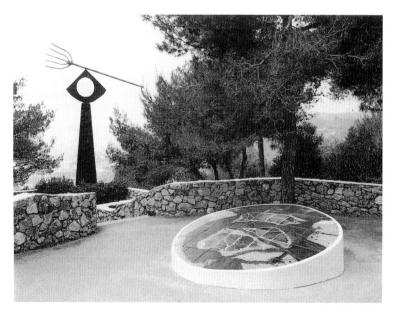

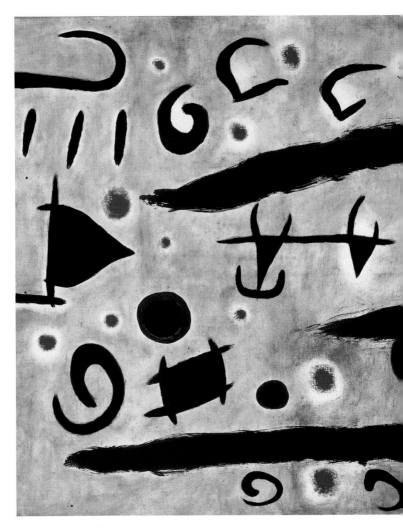

■ Mobility/Immobility

That great pioneer of abstraction, Wassily Kandinsky, had remarked how Miró was able to make the forms in the space of his pictures move about and telescope so as to create perpetual motion: "This little man who paints such large canvases, a volcano bubbling with images," he wrote, unable to conceal his admiration. It is true that Miró wanted to hurl his forms onto the canvas like sparks that would "burst out of the frame like a volcano." Stimulated by an interest in Persian prints that he had developed at the beginning of the 1920s (he had seen examples as early as 1913 at the Dalmau gallery in Barcelona), as well as by Japanese art, the expression of Miró's pictorial vision reduced drastically in scale and zeroed in on the contradictory forces that govern shapes which now appear as simultaneously mobile and motionless: "Precisely because they are immobile, [my forms] suggest motion. Because there is no horizon line nor indication of depth, they shift in depth. . . . You could even say that although they keep their autonomy,

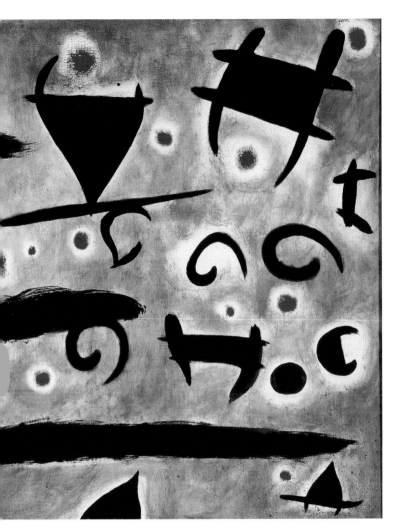

they push each other around" (Rowell 248). In 1962, Miró explained to the art critic Denys Chevalier the extent to which the creative energy of the Dada movement had convinced him to paint "without premeditation, as if under the influence of a dream. . . . In 1917. . . I met Marcel Duchamp and Picabia in Barcelona. Afterwards, and even in my portraits, where I tried to capture the immobility of a presence, my art became freer and freer. I tried to get the vibration of the creative spirit into my work" (Rowell 264,

263). In this way, Miró tries to capture "the absolute of nature" and demonstrates an attraction for a kind of pictorial vacuum, as for example in the dilute ground inscribed with scattered graphic marks in *Figure Throwing a Stone at a Bird:* "(Immobile things become enormous, much more enormous than things that move.) Immobility makes me think of vast spaces that contain movements that do not stop, movements that have no end. As Kant said, it is a sudden irruption of the infinite into the finite" (Rowell 248).

Figures and Birds Dancing against a Blue Sky: Sparks, 1968, oil on canvas, 68 ½ × 115 in. (174 × 292 cm). Musée National d'Art Moderne, Centre Georges Pompidou, Paris. Photo CNAC/MNAM.

■ Mont-roig, Vines, and Olive Trees

In a letter of July 1918 to his friend Ricart, Miró wrote: "Right now, what interests me most is the calligraphy of a tree or a rooftop, leaf by leaf, twig by twig, blade of grass by blade of grass, tile by tile. This does not mean that these landscapes will not finally end up by being Cubist or wildly Synthetic" (Rowell 54). As was his wont, Miró then started on several pictures at the same time. Back in Mont-roig a year later, he set to work again. In the morning, he returns to *Mont-roig, the Church and the Village* while in the afternoon he paints *Vines and Olive Trees*: "I am making one of the village as simplified as I can, trying to solve as many problems as possible so as to reach a balance. I don't know how the one of the olive trees will turn out; it started out being Cubist and now it's becoming *pointilliste*" (Rowell 62). While pursuing this detailed analysis of nature,

Miró turned increasingly to the calligraphic aspects of landscape. He accentuates the regularity of the furrows in the foreground and the pattern of the fields. Flat tints of color set at an oblique angle shore up the overarching formal rhythm, animating the composition through hints of relief in the landscape. Entirely reconfigured, the link to the real is no longer dependent on conventions of perspective. In the foreground, for example, the holes dug for the vine stocks are viewed from above, these nine circles forming a border that runs along the bottom of the picture. With consummate freedom, Miró lays the stress on precise zones, all the while synthesizing forms or treating others geometrically in an effort to convey his personal vision of the landscape observed from a window in his room. He is exploring and progressing, striving, as he put it himself, for "a pure art, entirely free yet classical."

Mont-roig, Vines and Olive Trees, 1919, oil on canvas, 28 ⅓ × 35 ½ in. (72 × 90 cm). Metropolitan Museum of Art, New York. Jacques and Natasha Gelman Collection.

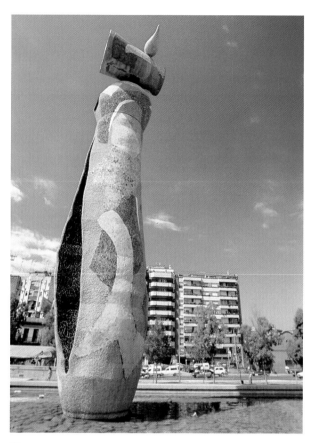

Monumental Sculpture

In addition to the large ceramic* murals (thirteen in all) produced with the assistance of Llorens Artigas*, Miró met with many further opportunities to realize and proselytize for his dream of integrating into the urban fabric an art that would exemplify that "anonymous" creative power in which he so fervently believed. Made in 1966, the *Sea Goddess*, an enormous female body resembling a reclining column, was subsequently submerged off Juan-les-Pins in the underwater cathedral of Formigue: although then hidden from view, it was for Miró a symbol of that Mediterranean culture that underpins his entire oeuvre. The majority of these monumental sculptures are magnified versions of pre-existing pieces often reworked at various stages in the process of enlargement. *Chicago Miss*, for example, for which a twelve-foot (3.75 m) bronze and cement model had been made in 1968, was set up in that city in 1981, then reproduced on a reduced scale for a terrace at the Miró Foundation* in Barcelona.

In 1982, *Personage and Birds*, a large-scale painted bronze measuring fifty-five feet (16.8 m), was erected in the garden of the Texas Commerce Bank, a

Woman and Bird, 1981–82. Joan Miró Park, Barcelona.

building designed by the architect I. M. Pei. The last and most famous of these pieces, *Woman and Bird,* was inaugurated in 1982 in the Joan Miró Park in Barcelona, located close to the bullring on the Plaza España. Its lofty form towers seventy-eight feet (24 m) and is indicative of the status Miró now enjoys in contemporary Catalan culture: consisting of kaleidoscopic fragments of pottery, it is a patent homage to Gaudí's mosaics in the Parc Güell. Woman is here represented as a great phallic pillar, her head crowned with a golden crescent.

An earlier ten-foot (3 m) version realized in 1952 stands in the gardens of the Fondation Maeght* at Saint-Paul-de-Vence.

Murals

"I want to introduce ceramics into architecture. They do it, for example, in Brazil, in sun-drenched countries where the light dances over the architecture. They do it in Portugal too." This allusion to Portuguese *azulejos* voices Miró's interest in the mural as a way of furthering his abiding concern to engage more directly with the public. These monumental ceramic pieces consist of elements fired separately before being assembled: the first two, the *Walls of the Sun and the Moon* were ordered in 1955 to decorate the gardens at the headquarters of UNESCO in Paris. Three preliminary models were designed and provided with a color scheme by Miró, the last being executed life-size

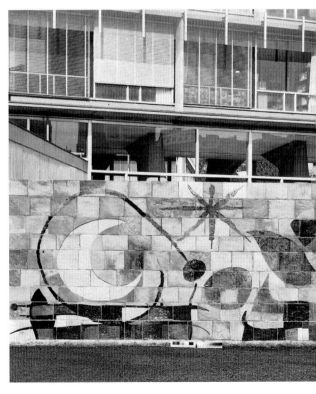

and erected among the rock cliffs of Gallifa in order to gauge its expressive power. The painter's most important points of reference for the project were the rock paintings in the Altamira caves, Catalan Romanesque frescos, and the mosaics by Gaudí in Barcelona's Parc Güell. Miró recounts the story of this vast undertaking in a 1958 number of Adrien Maeght's review *Derrière le miroir*. Two years after the UNESCO building, Harvard University commissioned a ceramic mural of six and a half feet by nineteen and a half feet (2 × 6 m), proportions comparable to those of the huge painting he had already completed on the same premises in 1951. Without preliminary models this time, Miró

plunged in, deploying thick black lines that seem all the more violent and lyrical as they were applied by hand with a pointed wooden stick directly on to plaques coated in a grayish glaze whose final colors are only revealed after firing. These early mural collaborations between Miró and Artigas greatly impressed those who saw them and soon orders were flooding in: at the Maeght Foundation* at Saint-Paul-de-Vence, the project for a "Fantastic Labyrinth" in the gardens was completed in 1968 by a thirty-nine-foot (12 m) long wall-painting. In 1970, in Spain itself, the artists installed a mural, 162 feet (50 m) in length by 32 feet (10 m) in height, for the frontage of Barcelona Airport, and later the headquarters of IBM, as well as paving for the Rambla at Santa Monica. Other projects included the Guggenheim Museum, New York, and another designed especially for the International Exhibition at Osaka in 1970. All in all, they were to carry out thirteen ceramic murals together.

Wall of the Moon, 1958, ceramic. UNESCO Headquarters Building, Paris. Photo Bridgeman.

■ New York

It was a debut retrospective in this city in 1941–42 that markedly enhanced Miró's reputation in the United States. In fact, it was in the U.S. that his international fame was consecrated, whereas at the time it had not been acknowledged in Spain (except for Barcelona). In Paris at the same period he was regarded primarily as a Surrealist painter, that is to say, as practicing a somewhat sanitized avant-gardism: the painter was defended solely by the poets whose works he had illustrated, though he was also championed

by Jean Cassou, then conservator at the Musée d'Art Moderne de Paris which had recently opened in the Palais de Tokyo. Yet institutions were still not buying him. On the other hand, since 1932 Miró had been very actively represented in New York by Pierre Matisse's gallery, and there his renown was attaining new heights, especially following the exhibition of the *Constellations* series in 1945. Miró was to stay in New York from February to October 1947 while he painted a vast mural for the restaurant of the Terrace Palace Hotel in Cincinnati. Unambiguous in its decorative intent, the rhythmically arrayed figures and broad, flat areas of pure color are well suited to the composition's uncommon surface area. The impact on Miró of the vastly different scale and lifestyle of America was, he said, like "a jab in the chest." After years of voluntary seclusion that had lasted until 1947, he met up with friends such as Alexander Calder, Yves Tanguy, Amédée Ozenfant, and Marcel Duchamp, who had been residing in the U.S. since the war. In America, Miró became aware that, paradoxically, the primitive magic of his work matched the dynamism of modern life. Local critical reaction too was enthusiastic, and his influence on an entire generation of young American painters was long lasting. Public recognition of his work was further confirmed by a second retrospective at the Museum of Modern Art, New York, in 1959—an opportunity for a second visit to the United States, during which Miró garnered many visual ideas which he was to put to good use during a final very creative period.

Nocturne IV,
1938, oil on cardboard,
21 ¼ × 28 ¾ in.
(54 × 73 cm).
Private collection.
Photo Bridgeman.

■ Nocturne

The world that comes into being at night is a strange one. Beneath the light of the stars, huge creatures emerge, lumbering through a hallucinatory space and attending on the stars as if at some ritual festival. Playing on a strict contrast between opaque black and dazzlingly bright colors, Miró divides the space neatly into two: at the top, the dark sky, below, the fiery earth. It is impossible to identify the weird beings filling the scene. Such enigmas are, however, part of Miró's genius. In a letter to Margit Rowell, André Masson wrote that one day, as Paul Eluard was heaping praise on a solar symbol in

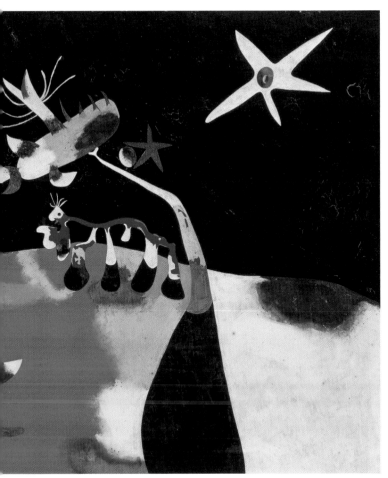

a painting of 1924, Miró observed that the object in question was actually a potato. Such humor epitomizes an oeuvre in which a childlike playfulness allows any object named to be replaced by any other, just for fun. The artist attaches no real importance to their supposed coherence: reality lies elsewhere, in the shock felt on contact with the work. Miró favored the night, a time for dreams, for letting the mind wander, a time when things take on a more mysterious form, beings and objects undergo a metamorphosis, and everything looks uncanny—before it all scatters in the clear light of day. The nocturnal world is one we can all escape into. In Miró's pictures, the ladder* we climb to make our getaway serves as a bridge between earth and sky and leads up to the stars. Miró himself liked to say: "I am overwhelmed when I see a crescent moon or the sun in an immense sky. . . . One of the most exciting experiences I have ever had was flying over Washington at night. Seen at night from an airplane, a city is a marvelous thing" (Rowell 247). In the darkness, one can only make out the twinkling lights. There remains ample scope for the imagination: Miró gives physical presence to the images that stream out of his unconsciousness.

■ Painting

Between 1949 and 1950, Miró produced numerous canvases that Dupin has classified into two categories: "slow" paintings painstakingly worked up and "spontaneous" ones that seem to shout out loud. Miró would return repeatedly to the "slow" works until the required feeling of balance and completion was achieved.

The "spontaneous" paintings, on the other hand, would be carried out with physical impulsiveness and unmediated gesture. During these two years, the painter would thus move to and fro between application and improvisation. The spontaneous paintings were executed on canvas, paperboard, or masonite, using oilbased paint, gouache, charcoal, pastel, or watercolor. Other less orthodox materials might be added, such as the lengths of string visible here. In *Painting*, the painter's impulses and speed of execution, the vigor of his gesture, are palpable. Unscripted, Miró hurls blobs of paint onto the canvas, creating a riot of anarchy; tangles of string attach themselves to the drawings. So closely do they echo the carefully delineated figures that they seem like refugees from the "slow" paintings. Essential components of Miró's repertory, these creatures undergo a further transformation: settling onto the shifting ground, their precisely outlined forms drenched in color contrast with the hustle

Painting, 1950, oil, string,
and casein on canvas,
43 × 30 in. (99 × 76 cm).
Stedelijk Van Abbemuseum,
Eindhoven.

and bustle that otherwise characterizes the composition. Reminiscent of a blazing fire, the clumps of red and yellow, partially concealed behind puffs of black smoke, churn about in disorder. Splashes of paint overlap, building into strata that are arrayed with drawings and signs: the ones behind are visible only where they show through. On the surface, the relief provided by the knots of cord accentuates still further the sense of depth stemming from the extreme profusion of the painter's gestures.

■ Painting-poems

Miró's poetic writings appear liberally in his private notebooks which, year after year, record every stage of his work in progress. Sometimes he would cut out sections of his journal and introduce them into paintings, drawings, or lithographs, or look through them for a title for a picture. Miró had first placed written words in an image as early as 1917, in *Nord-Sud*, so beginning to reflect on the visual and plastic qualities of his personal writings. From 1924 on, numerous "word-rhythms" crop up in canvases and drawings: *Bass, Gin, Ma jolie, Jour, Vi, Sard, Yes, Gentleman, Ah! OOO!, Tic Tic*. . . . The move to "painting-poems" initially occurred in *The Smile of My Blonde*. In 1925, a complete sentence ("The body of my dark-haired woman because I love her like my pussycat dressed in salad green[,] the flame of her phosphorescent eyes falling like hail, it's all the same") originally transcribed in one of his notebooks, set the tone and overall atmosphere for

a picture entitled *The Flame of Her Phosphorescent Eyes.* Genuine "title-poems" appeared only in 1931, though they remain discreet, providing isolated descriptive clues: they are image-titles, like the famous *A Star Fondles a Black Woman's Breast* in 1938. The words later started to adhere to the actual substance of the picture, with a genuine visual correlation

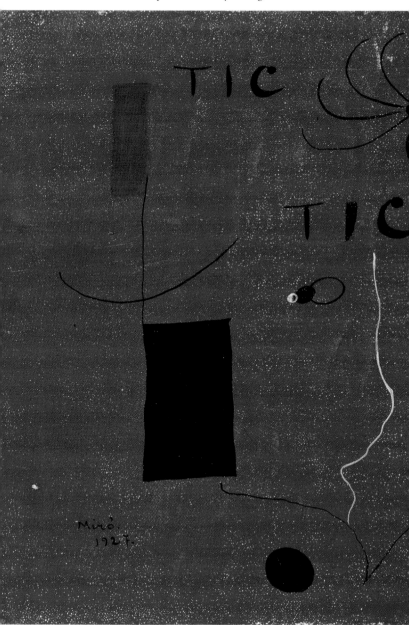

between painting and poetry. By and large, these titles came to the artist during the act of painting: in fact, these "word-images" are never intended to designate a real subject (at that time predominantly women and birds), but rather to add a myth-like resonance to the pictures, as in a title dated 1940: *On the 13th, the Ladder Brushed the Firmament*....

Tic Tic, 1927, oil on canvas, 9 ½ × 13 in. (24 × 33 cm). Kettle's Yard Museum, University of Cambridge, Cambridge. Photo Bridgeman.

86

Paintings on White Background for the Cell in Solitary

This triptych is surely the most thoroughly simplified work Miró ever produced. A radical statement, it goes beyond painting, extends Miró's own visual experiments, and delves deep into the heart of poetry. With none of the density of the anthropomorphic marks or the symbolic signs that for so long inhabited his art, this work is more a meditation on the void and a reflection on the power of line. The line itself feels as weightless as a thread drifting to the floor, as brittle as a hairline crack: a greater economy of means in a triptych of such dimensions is hard to imagine. If the line seems virtually nonexistent, it must still have required all the artist's powers of concentration, for it extends an inordinate length, like a vibration in the silence. First diagonal, then vertical, then oblique once again, it also evokes Japanese calligraphy: two years previously, Miró had visited the Land of the Rising Sun, where he had met the poet Shuzo Takiguchi, who had composed the first monograph about him in 1940.

The painter felt a deep kinship with the spirituality of Japan*. The triptych ordains a space of loneliness and meditation, advancing concrete proof that the painter has succeeded in reaching the summit of the ladder*, in making his escape, in propelling himself beyond painting: "For me, this simple line shows I have earned my freedom. And, for me, to attain freedom is to attain simplicity. So, at bottom, one line, one color is enough to make a picture."

Photograph: This Is the Color of My Dreams

Photograph: This Is the Color of My Dreams is one of Miró's most enigmatic canvases. The only trace of paint visible on the virtually blank surface is a blue spot, like a smudge of ink on a sheet of paper. This form is accompanied by a caption—a sentence written out neatly as if on the lines of a schoolbook. The hand is that of a diligent pupil. The single word, "photo," top left, imparts balance to the canvas. Miró's penmanship is deliberate. The alternation between the up and down strokes, the fragility of the line, and the vitality of the impasto

Paintings on White Background for the Cell in Solitary, triptych, 1968, oil on canvas, 106 ⅓ × 139 ¾ in. (270 × 355 cm), 105 ¼ × 137 ¾ in. (267 × 350 cm) and 105 ¾ × 138 ⅔ in. (267.5 × 351.5 cm). Fondació Joan Miró, Barcelona.

Photograph: This Is the Color of My Dreams, 1925, oil on canvas, 38 ¼ × 51 ¼ in. (97 × 130 cm). Collection of Mme Pierre Matisse, New York. Photo Bridgeman.

accentuates the outline of each letter; the arabesque on the *P* is particularly ornamental.

But why the word "photo"? Does it stand for a relationship to time, the instantaneity of the dream, or for the exact moment when the photographic act refers us back to the reality it captures? The laconic nature of the picture leaves room for all kinds of interpretation. In 1925, Miró was close to the Surrealists. He especially shared their interest in the dream and the subconscious through which an alternative reality can be attained. Their researches chimed with his quest for new working methods. He was also at one with the Surrealists in believing that poetry ought to fuse with visual imagery. What is essential for Miró is that painting, whatever it may be, should provoke reactions in the observer. No one knows what will happen when they see *Photograph: This Is the Color of My Dreams*. Miró simply allows our imagination and our dreams to run riot.

■ Poetry games

A friend of poets and an illustrator of verse, Miró could on occasion step forward as a poet on his own account. His writings, however, have their roots solely in his experience and efforts as a painter, and he never regarded them as autonomous creations. The words run on, drawn with the same pencil and on the same sheets of paper as preparatory studies, technical notes, or observations on future pictures or books, as lists of paints to buy, remarks, projects, declarations, etc. Miró's *Catalan Notebooks** constitute an inventory of work in progress and provide

a forcing ground for his inspiration. However, in response to reiterated requests from two legendary publishing figures, Tériade (the creator of the review *Verve*, and editor of the Surrealist review *Minotaure*) and Christian Zervos, founder of the *Cahiers d'Art*, Miró did allow some texts to be printed, and the *Harlequin's Carnival* (dated in his *Notebooks* October 10, 1938) came out a few months after the first mention of it appeared in the journal *Verve*. Written eleven years after the canvas of the same name which it attempts to clarify, Miró's text proves more perplexing than the picture, filled as it is with the "hallucinations brought on by hunger" that he experienced while living in straitened circumstances on rue Blomet. Its lyricism owes a heavy debt of inspiration to Lautréamont's *Chants de Maldoror* and to Mallarmé. In spite of its unconstrained, disorienting intricacy, on publication it was hailed by André Breton as a "poem in freedom."

Miró himself dissented from the term "poem," however, preferring the title *Jeux poétiques* ("poetry games"). A series bearing this title appeared in 1946 published by the *Cahiers d'Art*: the free verse flowed in an uncontrolled verbal torrent, in spontaneous combinations of words, sounds, and reminiscences characteristic of the automatic writing dear to the Surrealists. At the demand of publisher Louis Broder, in 1971 Miró's writings scattered in notebooks, canvases, and reviews were anthologized in a book illustrated by the painter called *Le Lézard au plumes d'or* in which calligraphic poems are intermixed with lithographs.

PRINTMAKING AND ENGRAVING

Miró was intent on juxtaposing images from his paintings with words written by his poet friends. To this end, he drew his first lithograph in 1930 for Christian Zervos' *Cahiers d'Art* and produced his first drypoint in 1933 for Tériade's journal, *Minotaure*. He then joined up with the Cubist painter Marcoussis, who taught him the rudiments of engraving on copper. In 1938, the twenty or so prints Miró had worked on at Marcoussis' press were pulled at the Roger Lacourière studio in Montmartre, where Miró also met up with Picasso. In New York, where he was to spend several months in 1947, Miró met the painter and engraver Stanley W. Hayter, who had founded the celebrated Atelier 17 where so many of the rising stars of American painting, as well as a number of European artists in exile, were to be initiated into gravure. It was in Hayter's workshop that Miró got to grips with the techniques of etching and aquatint. Back in Paris, from 1948 he worked at Lacourière's in close collaboration with Jacques Frélaut. In 1948 too, aided by his Paris dealer Aimé Maeght, he joined forces with Fernand Mourlot, a printer with whom Picasso, Braque, Matisse, Rouault, Masson, Léger, and Giacometti had all worked. Over the following thirty years, with the printer's assistance, he was to produce hundreds of original lithographs for catalogs and posters published by Maeght. In Barcelona, Miró also frequented the print studios of publisher Gustavo Gili.

It is in lithography that the most fruitful results of the metamorphosis of Miró's language are to be sought. Since it provided the ideal channel for his impulses, the artist seems to have favored drypoint, a technique in which the metal plate is attacked directly, with no allowance for second thoughts. In 1975, in Maeght's new printshop at Levallois, Miró produced a collection of forty-five plates in drypoint he dubbed his *Journal d'un graveur*. Miró's final years were particularly productive in this field, with ten illustrated books, more than one hundred lithographs, and more than two hundred engravings executed with various partners in Paris and Barcelona.

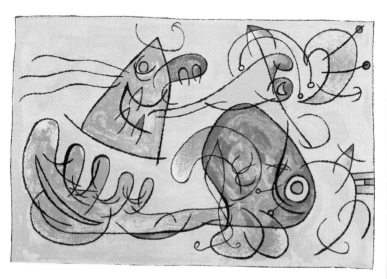

The Sleep of Père Ubu, 1966, lithograph, in *Ubu Roi*,
Editions Tériade, Paris.
Photo Joseph Martin/AKG.

■ Rue Blomet

"Rue Blomet was a decisive place, a decisive moment for me. It was there that I discovered everything I am, everything I would become" (Rowell 100). Miró set foot in Paris in winter 1920, taking up residence at 45, rue Blomet, on a small courtyard with a lilac tree and a handful of modest workshops. He was a neighbor of André Masson, whose studio stood immediately next door. Miró had already met Masson through the poet Max Jacob; the proximity of their studios led to a genuine warmth between them and their friendship ran deep. "Masson was always a great reader and full of ideas. Among his friends were practically all the young poets of the time. Through Masson I met them. Through them I heard poetry discussed. The poets Masson introduced me to interested me more than the painters I had met in Paris. I was carried away with enthusiasm for the novel ideas they brought and especially the poetry they discussed" (Rowell 208). Masson's workshop attracted friends such as the anthropologist Michel Leiris, whose fondness for exotic varieties of art Miró shared, the brilliant actor Antonin Artaud, whose declamatory prose called for the total liberation of the spirit, the painter Juan Gris, the poet Robert Desnos, the explorer of hallucination and hysteria Roland Tual, the writer Georges Limbour and his friend, playwright Armand Salacrou. They listened to music, read Byron, Jarry, Rimbaud, Lautréamont, Dostoyevsky, and Nietzsche, drank brandy and water or orange Curaçao. The poet Aragon wandered in from time to time; Breton and Eluard came to look at the pictures. Sometimes Picasso too would drop in on Miró. Dupin tells how on one of his visits, in 1924, Pablo had been hugely impressed by the *Spanish Dancer*. If Miró's studio was tidy, quiet, and calm, the atmosphere in Masson's was, in contrast, chaotic, verging on the unhinged. In 1924 Masson and Miró together discovered the painting of Paul Klee. For Miró, "more than anything else, the rue Blomet was friendship, and exalted exchange, and discovery of ideas among a marvelous group of friends" (Rowell 101).

Joan Miró working on a sculpture, c. 1950. Photo Rue des Archives.

■ SCULPTURE

Miró started working in three dimensions only in 1929: in this, he later recognized the decisive impact of the sculptor Jean Arp with whom he shared a studio on rue Tourlaque in Montmartre. After 1940, however, Miró strove "to escape from Arp's concretions." At this juncture, sculpture acquired a prominence in his oeuvre that was to gather momentum through to the end of his life. Whereas painting was a path from the intangible to the real, sculpture facilitated an immediate contact with the everyday, concrete elements which the artist could then project into an imaginary realm. In his notes Miró writes that he wants to make "something grandiose [and] reminiscent of Easter Island."

He particularly enjoyed working in the open air: "When I'm staying in the countryside," he remarked, "I never think of painting. On the contrary, it's sculpture that interests me. For example: it rains, the ground is damp. I pick up a lump of mud . . . it becomes a little statuette. A stone can dictate a form to me. Painting, being more intellectual, is for the city." Taking his cue from anything he might stumble across (scraps of iron, stones, etc.), he then did his utmost to make the forms blend in with the majestic landscape around the Majorcan

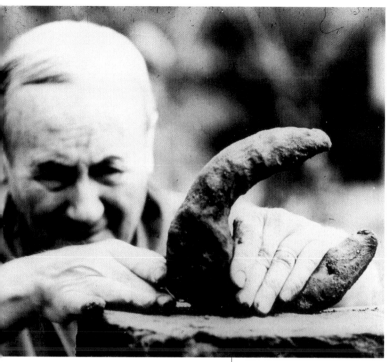

studio. Just as in his painting, it is the "magic spark" that counted when he set a project in motion. Miró would often make molds, harking back to architectural details in Gaudí—who "also made molds of various objects. . . which he would later use as models or starting points; I believe that my working methods have a great affinity with Gaudí's."

The other major influence in terms of sculpture came from the training Miró received at Francisc Gali's art school in Barcelona: its founder taught to draw from touch by holding an object behind one's back, kindling Miró's precocious desire to practice modeling. At first, his appreciation of direct tactility made him fancy that "cast in bronze, [his] sculptures, with rare exceptions, would look dead, [like] museum pieces." Nevertheless, by 1944–45 Miró was trying out little bronzes that were exhibited at the Galerie Maeght in Paris in 1950. From 1944 to 1950, he went on to produce ten major, if relatively small-sized, works, a few of which were reworked on a grander scale.

◼ Seated Woman

Gradually taking over the space of Son Abrines*, the vast studio he had for so long dreamed of possessing, Miró could at last find room to remove all his canvases and drawings from storage. Going through the work he had completed hitherto spurred him to strike out in a new direction. The path he settled on was one of the utmost freedom, and it compelled him to extend the limits of his art. In 1947, he went on a first trip to the United States, during which he discovered the American painting of the younger generation. A few years later, in 1952, on a visit to an exhibition of Pollock at Facchetti's in Paris, he was once again forcibly struck by the power of this new art. His second trip to New York in 1959 was a turning point: he

shifted towards unmediated expression, towards greater spontaneity*. Miró pushed himself to attain maximum intensity through the minimum of means: his rendering of nature becomes sparer and sparer, while form and color are simplified to the extreme. All that is left is an individual gesture through which Miró accedes to anonymity and attains universality.

This *Seated Woman* is one in a series of five. The heavy black strokes, accentuated by the broad, flat tint of yellow and by two daubs of red and green, result in a female figure reduced to its most basic elements. The drawing—or rather the script—monopolizes the picture space. With what is a handful of lines, Miró attains a force of expression that grasps the viewer's attention completely: if the gesture was immediate, to arrive at such a synthesis surely required prolonged meditation—and the image created calls for equally lengthy contemplation.

■ Self-Portrait

In November 1937, Miró wrote to his dealer* Pierre Matisse: "I am working a lot; my portrait was started several weeks ago, and, if I succeed, as I hope I will, it will be the most sensational thing I have ever done—in the deep sense of the word naturally, not in the affected sense, quite the opposite. An 80 P. [a standard medium-size stretcher] canvas, the bust only, representing a head about three times larger than natural size. A very elaborate work without, however, neglecting large masses and volumes" (Rowell 157). Three months later, he wrote to Matisse again: "The job is

Seated Woman I/V, 1960, oil and acrylic on canvas, 39 ⅓ × 32 in. (100 × 81 cm). Private collection.

93

SELF-PORTRAIT

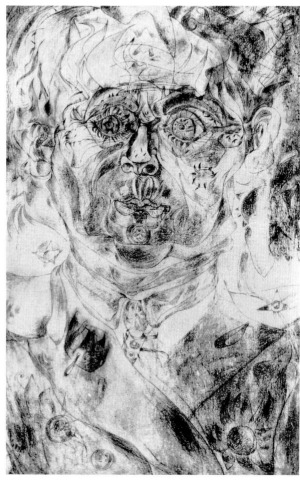

Self-Portrait I,
1937–38, pencil
and oil on canvas,
57 ½ × 38 ¼ in.
(146 × 97 cm).
Museum of
Modern Art,
New York.
Gift of Mr.
and Mrs. James
Thrall Soby.
Photo RMN/
J. G. Berizzi.

Self-Portrait,
1937–38/ February
23, 1960, pencil
and oil on canvas,
57 ½ × 38 ¼ in.
(146 × 97 cm).
Maria Dolors
Miró Collection,
Fondació Joan
Miró, Barcelona.
Photo Bridgeman.

going well. I have destroyed my portrait several times and now I believe I'm on the right track. . . . It will be a work that sums up my life, and will be very representative in the history of painting" (Rowell 158). Simultaneously, Miró was putting the finishing touches to his *Still Life with an Old Shoe,* convinced he had painted his two most important works since *The Farm.* He here returns to a realistic style. Employing a shaving mirror, he painstakingly transcribes every detail of his face—the modeling of nose, ears, chin, every feature of his appearance down to the hairs on his nose. The spirit of the portrait is, however, entirely whimsical: the painter peers out with a sun in one eye and a star in the other. Further stars swirl around him, ruffling his hair. The gap between the top lip and the nose is overstated and the naturalistic details around the eyes exaggerated. His gaze is that of a visionary. More than twenty years later, in the vast studio of which he was then dreaming, he was to return to several of his earlier efforts,

including the one here. Over it, he now painted a new version, a revision: a thick line shadows that of the first drawing, running round the eyes, head, and shoulders. The synthetic portrait, raw and black, superimposes itself over its predecessor and underscores its accents. Towards the rear, a painting within a painting, one can see Miró's eye encircled in red.

■ Siesta (The)

The Siesta belongs to that group of paintings that Rosalind Krauss and Margit Rowell have termed *Magnetic Fields*, in deference to Soupault and Breton's joint collection of automatic writing. In one of the preparatory sketches for *The Siesta*, a woman reclines in front of a house with a sundial; on a beach four figures dance, while a fifth bathes. An ass tethered to a tree plays with a ball. A bird lands on one of the rungs of a ladder. In the distance under a blazing sun one can glimpse the jagged mountain tops. By the subsequent composition, a radical change has taken effect; in a shift from detailed figuration to symbolic concision, Miró quits reality and enters a floating world populated by graphical signs.

The Siesta,
1925,
oil on canvas,
45 × 57 ½ in.
(114 × 146 cm).
Musée National
d'Art Moderne,
Centre Georges
Pompidou, Paris.
Photo Bridgeman.

He provides clues to the change in the *Catalan Notebooks**: "The eye of the woman is turned towards a number—Midday: a time for eating and sleeping." The white square terminating in a comma refers to the home and the silhouette of the woman. The sundial points to twelve— siesta time. To the right appears the body of a woman swimming, without weight or volume, suggested by the most fragile line. The circle of points ringing her form refers to the round-dance and harmonizes visually with the circular form of the sun. A line conjures up rugged highland peaks. The wealth of descriptive detail found in the earlier piece here gives way to few notations, aerial and unfet-tered by the conventions govern-ing Western painting—save for

the direction in which the picture is read. The spirit seems to have sloughed off the ponderous envelope of the body; the scene departs from the terrestrial sphere and strikes out for the absolute. The depth of the blue ground, energized by brushstrokes suggestive of the movement of the air, utterly absorbs the viewer.

▊ Son Abrines and the studio (Palma de Mallorca, Majorca)

"I dream of a big studio," Miró wrote in 1938, yet he had to wait almost twenty years for this dream to become reality. In 1956, his friend Josep Lluis Sert began construction on the hills above Calamayor in Palma, Majorca, close to Son Abrines, the house in which Miró was living. Finally confronted by this magnificent space, the artist at first rather lost his bearings. To feel it was really his to occupy, he packed it with all kinds of objects, an assemblage that soon mutated into a world full of bizarre creatures. Miró finally had sufficient room at his disposal to unpack works spanning many years that had been languishing in containers since before the war. He was fond of saying that at that time he had had to "reacquaint myself with work from a far distant time, back over almost my entire life." He then underwent a phase of self-criticism during which he destroyed a vast stockpile of canvases, drawings, and gouaches—though much remained that he felt able to return to. In this manner, Miró began reworking pieces that had been shelved, untouched, for

Joan Miró in the studio of his farmstead at Palma in 1967. Photo Daniel Frasnay/AKG.

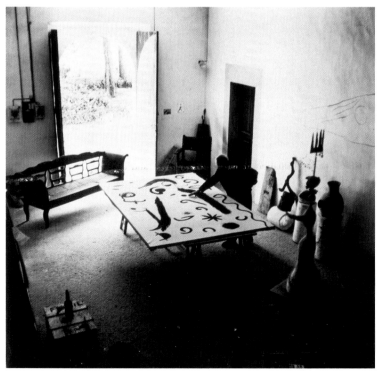

years. This bird's-eye view of his oeuvre urged him to throw off his remaining shackles and strike out on a fresh course—precisely as he had intimated during his second stay in the United States in 1959, when he had been pushed to extend the limits of his art.

This new mode of expression was brutal and direct, conveyed through a fresh spontaneity* of gesture in an impersonal approach that strove for universality. The new studio that had once appeared so enormous was soon overflowing. Miró went on to buy a spacious eighteenth-century residence close to his own, but that too was quickly full to bursting. He had expressed a desire that the workshops at Son Abrines and Son Boter be combined to form a Pilar and Joan Miró Foundation. The Foundation was later enlarged with a new exhibition building designed by the architect Rafael Moneo and inaugurated in 1992.

■ Spanish Dancers

Miró had embarked on a phase of violent reaction against the conventions that govern Western painting. In an outburst that echoes the revolt of Dadaism, he spoke of the "assassination*" of painting. He jettisoned the medium entirely and devoted himself to the less hackneyed technique of collage, the fortuitous juxtaposition of miscellaneous objects practiced by the Surrealists. For Miró, the purpose was to perturb our feeling of reality. At this time, he returned to one of his favorite subjects, the Spanish dancer, devising several variations on the theme, one of which exhibited an economy of means that beguiled the poet Paul Eluard:

"The *Spanish Dancers*—one cannot imagine a barer picture. A blank canvas with a hatpin and a wing-feather." Though these works derive from a real enough subject—the portrait of a Spanish dancer—they nevertheless lend themselves to abstraction. Built up in the most sparing manner, these constructions, which the title associates with a portrait, allow the imagination to roam free and conjure up the most evocative images. Following on from this series, Miró realized a group of collages in which popular imagery appears in the guise of picture postcards. But he no longer transcribes them, as he had done for the *Dutch Interiors** and the imaginary portraits, but incorporates them directly into the piece. The *Spanish Dancers* broke new ground for Miró. Abandoning the use of color and form by which, in the Western tradition, painting is constructed, and with no thought as to the durability of his creation, the artist plays with assemblages of different materials and textures. By exploring the transformations that can affect rubbish and detritus, Miró discovered a new means of expression.

The Spanish Dancer, 1928, collage-object: feather, cork, and hatpin on canvas, 39 ⅓ × 31 ½ in. (100 × 80 cm). Private collection.

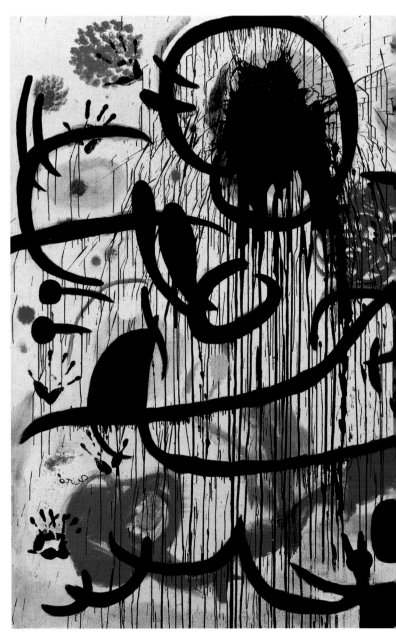

Spontaneity

Miró would often give himself up to energetic exuberance as he painted. Spots or streaks are catapulted onto the canvases, oozing out as frenetically as some illicit graffiti on a wall: a picture titled *May 68* is a particularly eloquent example of the impulsive gestures the artist was unleashing still more wildly at this stage in his career. Early on, Miró had declared that he wanted "to work in a single breath" and to operate on the same level of spontaneity in painting and drawing alike. Already in the 1920s, he would work under the influence of hallucinations brought on for the

basic ideas. Combined with the legendary discipline of his daily routine (the sacrosanct "cleaning of the brushes"), materials themselves (watercolor, rubbed pieces of paper, burlap) could also provide creative stimuli. As he wrote: "It is from accidental things that originality arises." Above all, the painter wanted the viewer to intuit the picture's "starting point," its primal physical impulse, so that the unmediated sensations and feelings on which his desire to paint was predicated kept all their freshness in the finished work: "For me a painting has to give off sparks. It must dazzle like the beauty of a woman or a poem.... Even more important than the picture is what it gives off, what it projects" (Rowell 251).

Still Life with an Old Shoe

The Spanish Civil War erupted in 1936. By the start of 1937, Miró had accepted that in the foreseeable future he could no longer hope to return to Barcelona and to the works he had begun there. In Paris, in a room lent him by his dealer* Pierre Loeb on boulevard Blanqui, he decided to channel his energies into something quite different from anything he had tackled previously: a series of highly realistic still lifes. *Still Life with an Old Shoe* was painted from an actual scene. Opposite him, the artist set up a table on which he placed an empty gin bottle wrapped in a sheet of paper tied with string, a large apple with a fork stuck into it, a hunk of black bread, and a worn-out shoe. Miró's avowed intention was to paint a picture powerful enough to compete with a Velázquez still life. The realism he adopted was by no

May 1968, 1968, acrylic on canvas, 78 ¾ × 78 ¾ in. (200 × 200 cm). Fondació Joan Miró, Barcelona.

most part by the frugal life he was leading in the rue Blomet studio: a cracked wall, a looming shadow is instantaneously transposed into a motif and captured on canvas or paper. At that time he was tearing up newsprint and composing collages that would then serve as a springboard for many of his

101

means photographic; it served instead as a way of entering into the essence of things, as an expression of a profound, mesmerizing reality. Informed by the unblinking observation of every detail, Miró painstakingly delineates nature from every angle the better to set his imagination free. The objects depicted can now embark on a new life: liberated from the contingencies of reality, like living beings they take possession of the picture, invading a space made all the more dramatic by the predominance of dark shadows. The menacing colors, the disturbing shape of the bottle, the overwhelming presence of an oversized fork plunging its six teeth into a withered apple, and the forlorn shoe in the foreground, eminently capture the horror of the Spanish political situation. The owner of the picture, James Thrall Soby, compared it to Picasso's cry of righteous anger in *Guernica,* dating from the same year.

Still Life with an Old Shoe, 1937, oil on canvas, 32 × 45 ⅔ in. (81 × 116 cm). Museum of Modern Art, New York.

■ Surrealism

In his first *Manifesto of Surrealism,* issued on October 15, 1924, André Breton defined Surrealism thus: "Psychic automatism in a pure state by which one proposes to express—verbally, by means of the written word, or in any other manner—the actual functioning of thought. Dictated by thought, in the absence of any control exercised by reason, exempt from any aesthetic or moral concern." Breton believed in conflating the two states of dreaming and factual reality into an absolute reality, into a "surreality." For him visual art must rely on this purely interior model or *il ne sera pas*—it will cease to exist. This revolutionary attitude sounded like a call to arms to Miró, then searching for new paths to follow. As he affirmed his independence as a painter and his unwillingness to be absorbed into the group, his relations with the Surrealists were to loosen. Having declared in *Surrealism*

and Painting (1928), that Miró "could pass for the most 'surrealist' of us all," Breton was then to write with respect to the artist's distance from the movement: "Miró's turbulent entry upon the scene in 1924 marked an important stage in the development of surrealist art. His work up to that point had demonstrated artistic gifts of the highest order limited only by a certain intellectual hesitation, but now at one bound he cleared the last obstacles that still barred his way with total spontaneity of expression. From then on, his output places on record an innocence and a freedom that have remained unrivalled. It is by no means impossible that his influence on Picasso constituted a determinant factor in the latter's decision to throw his lot in with the surrealists two years later. The one negative aspect of Miró's undoubted aptitude has been a partially arrested development at the infantile stage which has left him unprotected against unevenness, over-production and playfulness, and has set limits on the scope of his testimony." Of this intellectual movement whose role had been critical to his development, Miró concluded: "I like Surrealism because the Surrealists did not consider painting as an end in itself. One must not worry about whether a painting will last but whether it has planted seeds that give birth to other things" (Rowell 215).

Frontispiece for *Le Surréalisme en 1947,* lithograph presented by André Breton and Marcel Duchamp at the Galerie Maeght, Paris. Private collection. Photo Bridgeman.

▨ Textiles

In his efforts to eschew what he called the over-intellectualized and earnest business of "painting-painting," Miró became interested in textiles. He was, however, equally adamant about dissociating himself from the field of tapestry work that he considered hackneyed and all too frequently no more than a lifeless transposition of a preexisting cartoon. Nevertheless, at the request of patron and art collector Marie Cuttoli, he agreed to permit high-warp versions of some of his paintings to be woven by the Aubusson loom workers. His canvas *Snail Woman Flower Star*, expressly painted as the basis of a tapestry, represents a considerable leap in his graphism, as well as in the incorporation of letters as signs: in its woven form, however, the piece was still a disappointment to Miró. Nonetheless, following an encounter with Josep Royo, a tapestry weaver at Tarragona, Miró began working in an unconventional mixed-weave technique that allowed him to transcribe all the spontaneity* of his art into wool. Miró called these free works *sobreteixims*. On a deliberately coarse weave, Miró's customary signs rub shoulders with other more incongruously grafted objects: the wool spurts out of the weft in tufts or braids; burlap is woven with knotted cotton or broken yarn. . . . The material—pierced, singed, darned—liberates itself from the dictates of traditional craft; sometimes real objects are added (worn-out gloves, a doormat, floorcloths, rags, dusters, an umbrella). Thanks to their patchwork effect, Miró viewed these creations enthusiastically, as a liberating game; his burlap *Sacs* can change shape, like carnival masks. To early audiencesthe series seemed sacrilegious, a perversion of the master's easel style.

If, at the time of their creation, the results were seen as iconoclastic, their youthfulness and panache can be better appreciated today. These *sobreteixims* were instrumental too in procuring for Miró three monumental tapestry commissions, for the World Trade Center, New York; the National Gallery of Art, Washington D.C. (at the request of the architect, I. M. Pei); and the Miró Foundation* in Barcelona. These three large-scale pieces revert to a more "classical" style and techniques, with greater rigor of expression and surface refinement.

Wool carpet, 1979, 295 ¼ × 196 ⅞ in.
(750 × 500 cm). Fondació Joan Miró,
Barcelona.

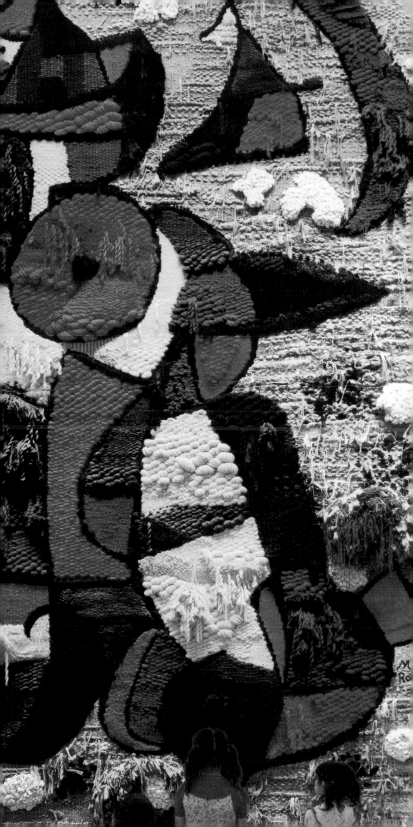

■ TILLED FIELD

Tilled Field, 1923–24,
oil on canvas, 26 × 39 in. (66 × 94 cm).
Guggenheim Museum, New York.

Miró's period of detailed observation of nature was succeeded by a phase in which reality is interpreted with such liberty that it gives rise to a totally fanciful universe such as one discovers here in *Tilled Field*. Although a mare and her foal, the odd insect, a dog, a house, a tree, etc., can be identified in this picture, all links with reality have been severed. The colors are fantastical, the scale exaggerated, the motifs stylized with extreme concision, while the positions of certain elements (the giant ear affixed to the tree trunk and the eye floating in the foliage, for example) are incongruous and invested with a symbolic charge. The organization of this baffling scene, in which nothing is depicted in classical perspective, seems anarchic. As soon as he started out as an artist, Miró came into contact with Dada, in particular through Francis Picabia and

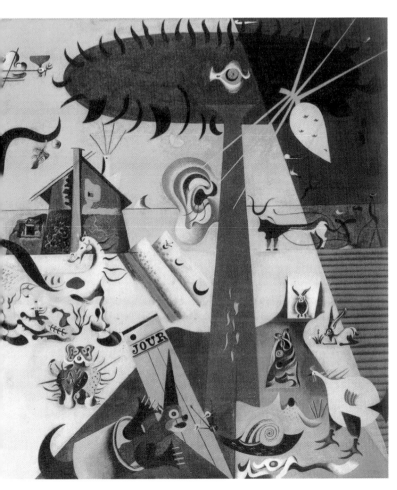

his review *391*, published in Barcelona. In Paris, while at rue Blomet*, he frequented the founders of Surrealism*, Aragon, Breton, and Soupault, who championed irreverence, black humor, and the overthrow of every accepted norm. For them, models were no longer to be taken from external existence: they had to be sought in an inner world. Their thinking had a major effect on Miró, who gave free rein to the ramblings of his fancy. Once back in Mont-roig in summer 1923, he painted *Tilled Field*, writing to his friend Rafols: "I have already managed to break absolutely free of nature and my landscapes have nothing to do with outer reality. Nevertheless, they are more *Mont-roig* than if they had been painted *from nature*. . . . I know I am following very dangerous paths, and I confess that at times I am seized with panic" (Rowell 82).

Bird, Awakened by the Piercing Cry of the Azure, Flying off over the Plain Which is Breathing (Oiseau éveillé par le cri aigu de l'azur s'envolant sur la plaine qui respire), 1968, oil on canvas, 53 ½ × 128 in. (130 × 325 cm). Helly Nahmad Collection, London. Photo AKG.

▨ Title-poems

Following the painting-poems of the mid-1920s, such as *Photograph: This Is the Color of My Dreams* or *A Bird Pursues a Bee and Kisses It*, Miró sought to avoid poetic titles.

After the series of *Constellations* executed in Varengeville in 1940–41, and, more regularly, from the end of the 1940s or beginning of the 1950s, he reverted to "title-poems" abounding in visual imagery, some lengthy, like monotone chants with an approximate syntax, others brief, like Japanese haiku: *The Tenderness of the Gleam of the Moon at Dawn Crossed by a Beautiful Bird,* 1954, or the still more allusive *The Embrace of the Sun to the Lover,* 1952. Linking various elements on the canvas, these titles would come to the artist as he worked, but Miró would grant them exclusively to paintings, "because a picture is a much more lyrical entity than a sculpture. A sculpture is more concrete, it exists in nature," and therefore is in no need of poetic metaphor.

But why all these titles? There was probably the desire to explore every aspect of a recurrent theme (*Bird and Woman in the Night*, for example, reappears several times between 1939 and 1967). But still more, there was Miró's mania for concatenating snatches of prose and expressions, for setting a word loose and watching it unfurl forever.

In the 1960s, title-poems were to accompany (like a lyric set to music) paintings whose ground was by and large "empty," enlivened only by a very few graphical gestures in the manner of Japanese

calligraphy: *Bird Awakened by the Cry of the Azure, Flying away over the Plain Which Breathes,* 1968, or more concisely the same year's *Waterdrop on Pink Snow.*

In proportion to almost two thousand works by the artist, however, these title-poems are very few in number, perhaps a hundred or so.

■ Tristan Tzara

Miró had shown enormous interest in the Dada movement from as early as 1917 when he had met Marcel Duchamp and Francis Picabia in Barcelona. During the artist's discovery of Paris at the beginning of the 1920s, the Romanian-born Tristan Tzara was one of the first poets—the other was Pierre Reverdy—with whom Miró struck up an immediate friendship, admiring him for the major role he had played in the Dadaists' clamorous entry into the French capital in the wake of the scandalous events they staged in March and May 1920. Through Dada, Tzara was plotting the subversion of middle-class values and artistic norms.

While still in Barcelona, however, Miró, in his involvement with the Agrupació Courbet, had already displayed his exasperation with bourgeois art and academicism. Spending the lion's share of his time in Paris with poets, it is no surprise that Miró quickly absorbed the Dada creed. "I have long considered [Tzara's] poetry to be of great spiritual value and his Dada position has always been extremely appealing to me" (Rowell 113). Coming to see him almost every day in the studio on rue Blomet (often with Artaud in tow), the poet was one of the first to truly appreciate the originality of Miró's painting.

It was Tzara who introduced Miró to the Cubist painter Marcoussis, who instructed him in copper-plate engraving. The first artistic collaboration between the two friends (Miró stresses that "he accepted gladly, without batting an eye" [Rowell 113]) was a book by the poet entitled *L'arbre des voyageurs*, published in 1930. Miró described his friend's verse as a "real desert, with the sand in blinding swirls," illustrating it with four lithographs. Later, when Miró was in New York at Atelier 17, run by the celebrated engraver Hayter (it was there he met a young American painter called Jackson Pollock), he produced eight etchings to accompany *Desesperanto*, one of the three volumes of *Antitête* published in 1947–48. Finally, the painter was to illustrate one of Tzara's discursive poems, *Parler seul*, brought out by Maeght in 1951.

Tristan Tzara (left), with Jean Arp (center) and Max Ernst, in 1920. Photo Rue des Archives.

Ubu

Miró's fascination with everything Alfred Jarry (1873–1907) wrote had begun in boyhood, and his pictorial and sculptural inspiration always felt at home in the writer's sarcastic, farcical world. Originally conceived as a puppet show before being staged as a play in 1896, *Ubu-Roi* (*Ubu Rex*) was written when Jarry was just fifteen as a skit on his math teacher. The piece transforms the unfortunate man into a grotesque parody of the bourgeoisie, hellbent on "remaking the world" with the aid of a *machine à décerveler* or "de-braining" machine. For the young Jarry, though, nonsense was quick to evolve into logic: this was the origin of his famous invention, Pataphysics, a "science of imaginary solutions" whose madcap laws were further developed in *Ubu Enchaîné* (*Ubu in Chains*) published in 1900 and first performed during the 1937 World's Fair. The

Title page for *L'Enfance d'Ubu*, lithograph, 1975, published by Editions Tériade. Musée National d'Art Moderne, Centre Georges Pompidou, Paris. Photo CNAC/ MNAM/ Philippe Migeal.

final sequel, *Ubu Cocu* (*Ubu Cuckolded*), was published posthumously in 1944. Miró took particular delight in a comically fantastical novel composed by Jarry in 1902, *Le Surmâle* (*The Supermale*), the tale of the sexual exploits of a "superman" who, falling passionately in love with a machine, expires exhausted in her/its arms. Miró's identification with the larger-than-life Jarry comes through in Tériade's 1966 edition of *Ubu-Roi*. He composed thirteen double-page lithographs for this edition; exactly as in the series of *Constellations*, the surface is extremely "busy," covered with zones of pure color offset every so often by a dynamic line. Though the profusion of gestures, Miró revives the grotesque yet erotic charge of the text. In 1971, the same publisher proposed to bring out *Ubu aux Baléares (Ubu in the Balearic Islands)*, a text with the loosest of links to

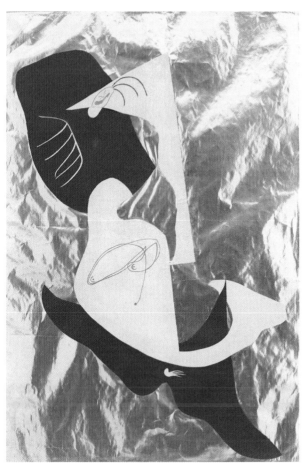

Jarry's original: it was in fact a poem composed by Miró himself in which Ubu, expelled from Poland, takes refuge on Majorca. Riddled with violent language and profanity, this outburst ran to six handwritten pages and was accompanied by twenty-five lithographs reminiscent in their spontaneity* of a child's drawings. A third volume, *L'Enfance d'Ubu (Ubu's Childhood)*, adopts a far pithier style, both linguistically and in the twenty-four lithograph illustrations: Miró did little more than assemble anonymous scraps of Majorcan poems, exclamations, and interjections. He even quotes Jarry's last words on his death bed: "A toothpick, *please.*"

Unreal reality

Miró would often alternate the detailed observation of reality with an imaginary realm, building into a rhythmic flux that was for him a source of a renewed strength. He always claimed that reality was the source and foundation of all his paintings. The attentive and concentrated observation of the real led to spiritual meditation. For him, "every grain of dust possesses a marvelous soul." It is the radiance emanating from nature that he tried to harness, reaching out to a second reality beyond the world of appearances. Ambiguously, his definition of reality coincides with the word "concrete." The artist attaches great

Drawing with collage, 1934, pencil and ink on black and white papers glued to aluminum foil, 27 ½ × 19 ¾ in. (70 × 50 cm). Collection Ernst Schwitters. Photo AKG.

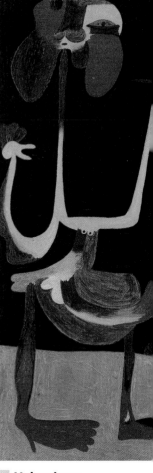

importance to the material aspect of his works: their particularly rich, muscular substance has the capacity to shock viewers before they have time to reflect. Similarly, at certain periods Miró could enlist the help of objects he had collected—lengths of string, worn-out bits and pieces—which he would then integrate into his compositions. Their instant impact refers us back to the real environment from which they were taken. Miró's intention is to escape from pictorial and naturalistic appearances; he wants to overcome painting, to explore a deeper reality, more internal, more personal. In an article published in the journal *XXᵉ siècle* under a title that translates as "True and false realisms in contemporary art," Miró advances his own definition of reality. It is not what one sees, but what lies within: "It is a deeper, more ironical, reality, indifferent to the one before our eyes; and yet it is the same reality. It need only be illuminated from below, by the light of a star. Then everything becomes strange, shifting, clear and confused at the same time. Forms give birth to other forms, constantly changing into something else. . . . It is like a kind of secret language made up of magic phrases, a language that comes before words themselves, from a time when the things men intuited and imagined were more real and true than what they saw, when this was the only reality" (Rowell 240). The signs he transcribes onto the canvas are a concretization of his mind: they do not express the reality of appearances but instead a network of inner forces.

Man and Woman in Front of a Pile of Excrement, 1935, oil on copper, 9 ¼ × 12 ⅔ in. (23.2 × 32 cm). Fondació Joan Miró, Barcelona.

■ Volcanisme

Volcanisme is the word André Pieyre de Mandiargues coined to describe Miró's controlled violence. However, he also mentions Miró's infinite gentleness, "all the more moving since it masks one of the most violently erupting craters to hit modern art in the last forty years." Many of Miró's paintings are assaults on the senses which strive for maximum power and visual belligerence so as "to affect the soul" and "attain an authentic expression of the mind." A first exhibition in Barcelona in 1918 was a fiasco, but from it he learned one crucial lesson: "How tremendously provocative, how

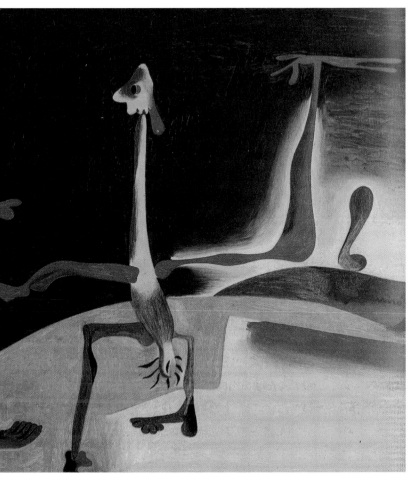

irritating something as apparently harmless like painting can be. . . . Ever since then, I've put my money on aggressiveness" (Rowell 297). Many pictures are striking in their violence. *Man and Woman in Front of a Pile of Excrement,* 1936, for example, gives vent in its title to the aggressive feelings that enflamed Miró as he foretold the catastrophes of the Spanish Civil War and the impending global conflict. In the late 1970s, he designed costumes and sets for a play titled *Mori el Merma* for which he also made contributions to the script. The audience reeled under the shock: "So much the better!" Miró stormed: "One has to hit hard.

Violence is liberating." Because Miró experienced these feelings deep within him, he is not the ethereal character that might be imagined from the fathomless blue of his paintings: "By nature I am tragic and taciturn. When I was young, I went through periods of profound sadness. I am rather stable now, but everything disgusts me: life strikes me as absurd. This has nothing to do with reason; I feel it inside me. I am a pessimist" (Rowell 1959). It is most probably this distress that lies behind the ferocious expressions of the monstrous creatures that sail, hidden among numerous other signs, through Miró's ever-shifting world.

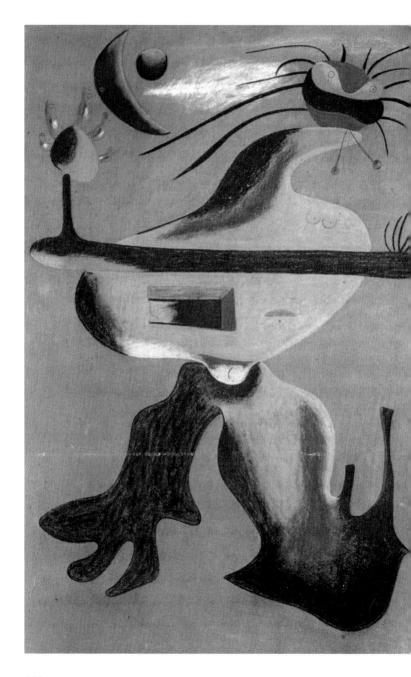

■ WOMAN

This figure belongs to a series in pastel from 1934 comprising fifteen large-scale works of indescribable cruelty. They precede the sequence of pictures called *Peintures sauvages* ("wild," "savage" paintings). Here, Miró too gives birth to monsters: can this be a woman's body? Confirmation comes only in the form of a pair of tiny round breasts. The tousle-haired skull that often denotes female figures in his painting also appears. The terrifying, wide-apart eyes, threatening talons, and thickset legs seem to crash through the paper. The stellar shapes floating at the top of the picture seem to be wrestling with the creature, and the absence of any sense of scale makes one doubt whether this is truly a depiction of a female body or a vast vegetal and mineral space. The belly is modeled like an enormous pebble, while beneath the horizon formed by the arms the viewer is intrigued by a gaping rectangular hollow: a window deeply gouged into the modeled form, like an abyss. A patch of sky peeps through, the only opening in a universe blocked off by a monochrome brown ground. The velvety pastel softness of this alarming image exacerbates the acidity of the yellow, emitting a dazzling glare. In Miró's art, woman often features in a diabolic or absurd guise. The question then arises as to why Miró, a man solicitously devoted to wife and daughter, should choose the female figure through which to convey such savagery and contortion. The image of woman seems to act as a trigger to Miró's pessimistic vision of humanity. Above and beyond that, the expressionist power that courses through this series of pastels has also been interpreted as an intuition, a revelatory sign, of the political barbarity about to engulf Spain and the rest of the world.

Woman, 1934, pastel on flock paper.
Private collection.

World in gestation

Monstrous, hybrid beings began to abound in Miró's two- and three-dimensional creations; the artist's credo had become "to create new beings, give them life, and make a world for them." In notes written in the years 1940–41, he excoriates his painting, lambasting it as "conventional," and declares himself better suited to creating "a truly phantasmagoric" universe in sculpture. His intention was that sculpture should "live" autonomously in the studio, as if it inhabited another, parallel universe. Each piece should be like a "real monster living in the studio—a world apart."

In painting too, Miró argued that the forms materialized as his work progressed. The way he makes the signs of imaginary writing emerge and turns forms into signs indeed resembles a process of "revelation." "Instead of setting off on a search for something to paint, I start to paint, and, as I do so, the picture starts to impose itself, making suggestions of its own beneath the brush. As work progresses, the form becomes a sign for a woman or a bird." "I paint without premeditation, as if under the dictate of a dream." The real and tangible world is of little interest to Miró, even if he confesses to admiring the "exceedingly rigorous" realism of a Vermeer, for example. He seeks instead to convey the forces that operate within us and is more attracted by anything connected to magic. In 1957, in an inspired reply to a survey carried out by the periodical *XXᵉ Siècle* about the definition of reality in artistic creation, Miró describes the realm in which his art operates as one in permanent change and gestation: "Forms give birth to other forms, constantly changing into something else. They become each other and in this way create the reality of a universe of signs and symbols in which figures pass from one realm to another, their feet touching the roots, becoming roots themselves as they disappear into the flowing hair of the constellations. It is like a kind of secret language made up of magic phrases, a language that comes before words themselves, from a time when the things men intuited and imagined were more real and true than what they saw, when this was the only reality" (Rowell 240).

The Potato, 1928,
oil on canvas,
39 ¾ × 32 ⅛ in. (101 × 81.7 cm).
Metropolitan Museum of Art,
New York. Jacques and Natasha
Gelman Collection.

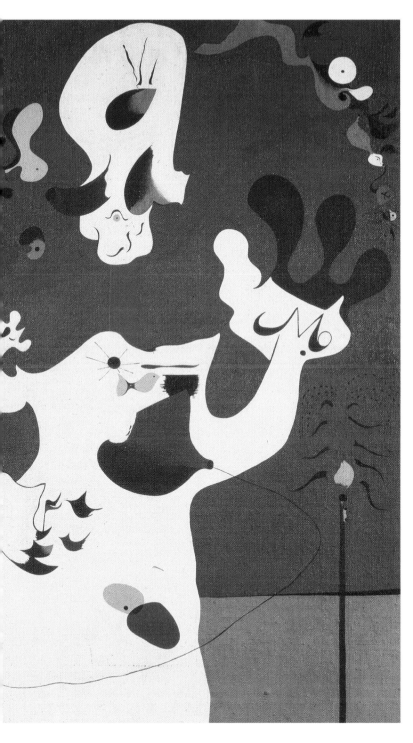

CHRONOLOGY

1893 April 20: Joan Miró Ferrà born in Barcelona. His father is a watchmaker and jeweler by trade; his mother is the daughter of the cabinetmaker, Josep Ferrà.

1897 May 2: birth of his only sister, Dolors.

1905 Begins sketching in pencil, charcoal, pastel, and red chalk.

1907 Enters a business school in Barcelona, concurrently following courses in drawing at the Llotja arts school.

1910–11 Works in a drugstore, then in a chemical factory; he falls gravely ill. After a deep depression he decides to devote himself solely to art. His family acquires a farm at Mont-roig that proves a great inspiration to the maturing artist.

1912–15 Studies at Francisc Galí's art school where he meets ceramist Llorens Artigas. His sketchbooks are filled with nude studies; he also draws street scenes and women dancing.

1918 Debut one-man exhibition at the Dalmau gallery in Barcelona that is an unmitigated failure. He founds the Agrupació Courbet.

1920 For the first time Miró travels to Paris where he meets Picasso; a relationship of friendship mixed with admiration binds the two artists.

1921 A second stay in Paris; Miró moves into Gargallo's studio on rue Blomet where he will encounter young writers (including Antonin Artaud, Jacques Prévert, and Raymond Queneau), forging many friendships. On April 29 Miró has his first show in Paris; this exhibition is also unsuccessful and his financial situation once again becomes precarious.

1922 *The Farm* is shown at the Salon d'Automne.

1924 He joins the Surrealist group under the leadership of André Breton.

1924–25 *Harlequin's Carnival.*

1925 June: his first solo exhibition at Galerie Pierre (Loeb), Paris, is a triumph.

1928 Travels to the Netherlands, the inspiration for the *Dutch Interiors* series.

1929 October 12: marries Pilar Juncosa; the couple settles in Paris.

1930 July 17: birth of his only daughter, Maria Dolors.

1931 Debut show at the Pierre Matisse Gallery, New York.

1934–36 Participates in various exhibits in Zurich, Brussels, Prague, Tenerife, and London.

1936 Civil war breaks out in Spain; Miró leaves the country and moves for Paris with his family.

1941 First retrospective at the Museum of Modern Art, New York.

1944 Works in ceramics and makes his first bronze and terracotta sculptures, including *Sun Bird* and *Moon Bird.*

1959 Awarded the Guggenheim Foundation prize for his murals at the UNESCO headquarters in Paris.

1967 The Carnegie Foundation, Pittsburgh, awards Miró its painting prize.

1975 Inauguration of the Joan Miró Foundation, Barcelona, to which the artist donates two hundred paintings, fifty sculptures, five thousand drawings, and the complete corpus of prints.

1983 December 25: Joan Miró dies at Calamayor, Majorca.

1992 December 19: the Pilar and Joan Miró Foundation opens in the artist's studio at Calamayor.

SELECTED BIBLIOGRAPHY

Bonnefoy, Yves. *Miró.* New York: Viking Press, 1967.

Cela, Camilo José and Pere Serra. *Miró and Mallorca.* New York: Rizzoli, 1986.

Dupin, Jacques. *Miró.* Paris: Editions Flammarion, 2004 (originally published by Ediciones Polígrafa, 1993).

Gimferrer, Pere. *Roots of Miró.* Barcelona: Ediciones Polígrafa, 1997.

Greenberg, Clement. *Joan Miró.* New York: Quadrangle Press, 1948.

"Hommage à Miró," special issue of *Cahiers d'Art XXᵉ siècle.* Paris, 1972.

Hunter, Sam, ed. *Joan Miró: His Graphic Work.* New York: Harry N. Abrams, 1958.

Lanchner, Carolyn. *Joan Miró.* New York: Harry N. Abrams, 1993.

Penrose, Roland. *Miró.* New York: Thames and Hudson, 1970.

Perucho, J. *Joan Miró and Catalonia.* London: Alpine, 1988.

Picon, Gaetan, ed. *Joan Miró, Catalan Notebooks.* New York: Rizzoli, 1977.

Rowell, Margit, ed. *Joan Miró: Selected Writings and Interviews.* Boston: G. K. Hall, 1986.

Tapié, Michel. *Joan Miró.* Paris: Celiv, 1989.

Weelen, Guy. *Miró.* New York: Harry N. Abrams, 1989.

Catalogues and catalogues raisonnés
[in chronological order]

Joan Miró: Magnetic Fields, 60 paintings 1923–68, with texts by Rosalind Krauss and Margit Rowell. New York: Solomon R. Guggenheim Museum, 1972–73.

One Hundred Sculptures, 1962–1978, with texts by Jacques Lassaigne, Jacques Dupin and Dean Swanson. Paris: Musée d'Art Moderne de la Ville de Paris, in collaboration with the Fondation Maeght, 1978.

Drawings, 509 works 1901–1978, with text by Pierre Georgel. Paris: Musée National d'Art Moderne, 1978–79.

Tryding, Nils. *Joan Miró: posters/affischer.* Malmö (Sweden): Malmö Konsthall, 1994.

Joan Miró: métamorphoses des formes. Saint-Paul-de-Vence: Fondation Maeght, 2001.

I N D E X

119

Translated from the French by David Radzinowicz
Copyediting: Linda Gardiner
Typesetting: Thierry Renard
Proofreading: Slade Smith
Color separation: Pollina s.a., Luçon

Previously published in French as *L'ABCdaire de Miró*
© Éditions Flammarion, 2004
English-language edition
© Éditions Flammarion, 2005

© Successió Miró - ADAGP, Paris 2004,
for all works by Joan Miró

www.editions.flammarion.com

04 05 06 4 3 2 1

FC0435-05-VIII
ISBN: 2-0803-0435-6
EAN: 9782080304353
Dépôt légal: 08/2005

Printed in France - n° L96445

Pages 4–5: Joan Miró at Palma de Mallorca in 1967.
Photo Daniel Frasnay/AKG.